HEATH LEDGER

LIVING BY INSTINCT

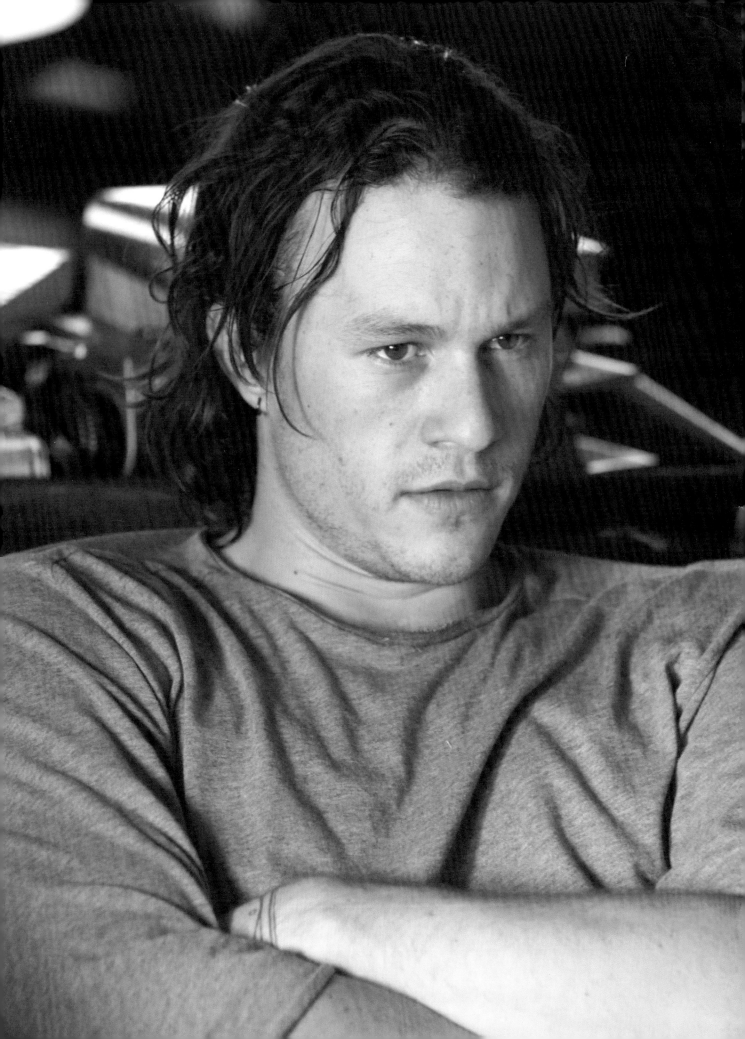

HEATH LEDGER

LEDGER

LIVING BY INSTINCT

RAY TEDMAN

Reynolds & Hearn Ltd
London

First published in 2010 by
Reynolds & Hearn Ltd
61a Priory Road
Kew Gardens
Richmond
Surrey TW9 3DH

CREDITS: 10 things I hate about you © Buena Vista Pictures; Brokeback Mountain © Focus Films;
The Brothers Grimm © Dimension Films; Candy © Think Films; Casanova © Touchstone Pictures;
The Dark Knight © Warner Bros.; The Four Feathers © Paramount; Home and Away © Seven Media Group;
I'm Not There © Weinstein Company; The Imaginarium of Dr Parnassus © Infinity Features;
A Knight's Tale Getty Images © Columbia; Monster's Ball © Lions Gate; Ned Kelly © Focus Features;
The Order © 20th Century Fox Corp.; The Patriot © Columbia; Roar Getty Images © Universal TV.
Photographs on pages 156-159 courtesy of Lighthorne Pictures/Naked City Pictures.
All other pictures Getty Images.

ISBN 978 1 905287 63 5

Designed by James King

Printed and bound in Malta by Melita Press

CONTENTS

ONE:

FOLLOW
YOUR HEART

*'I never studied acting in Australia. I never had an empty stage
and black pyjamas to run around and express myself'*

Heathcliff (Heath) Andrew Ledger – named by his parents after the stormy anti-hero of Emily Brontë's *Wuthering Heights* – began his acting career at the age of ten, playing Peter Pan. In the following years he took part in several more school productions, developing a passion for acting and for films. In 1993, by the age of 14, he was appearing in his hometown of Perth, Australia, in a local children's television show called *Clowning Around*, followed by regular appearances on another children's series *Ship to Shore.* His father Kim recalled a conversation with Heath after he picked him up late one night after a rehearsal: 'I'm going to have to get used to these late nights. I'm going to do really well in this industry – I love it.'

Heath had his first professional audition for another television series *Sweat* at the age of 15. Based on a school for athletically gifted youngsters, the programme – which ran for 26 episodes – gave him a regular role as Snowy Boles, a gay cyclist. At the audition he had been offered a choice of roles – the cyclist or

a swimmer. He chose the former. Although the series (and Ledger's performance) received lukewarm reviews, his first professional engagement reinforced his acting ambitions and, at the age of 17, he set out with his best friend for the bright lights of Sydney – 2500 miles to the east of Perth, on the opposite coast of Australia.

In an interview some years later Heath said 'I knew early on that no one is going to come knocking on your door, that you have to make your own luck – you have to go out there and knock yourself; it doesn't come easy.... All I had was 69 cents in the bank, plus a bit of cash my parents gave me.'

Heath's hard work paid off. In 1997 he made his movie debut in *Blackrock*, as a surfer (and rapist) in a film based on the real-life rape and murder of a teenage girl by a gang of surfers. The film, directed by Steve Vidler, premiered at Robert Redford's Sundance Film Festival. In same year Ledger had a small part in *Paw*, a vehicle for Australian guitar prodigy Nathan Calaveri. In common with many young

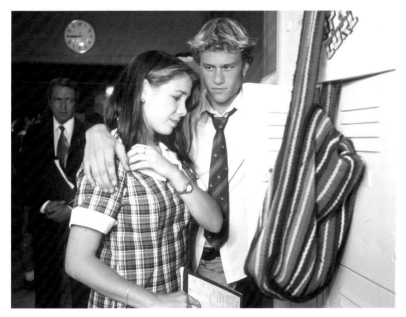

In *Home and Away*,
with Sally (Kate Ritchie)

Australian actors, he also appeared in the soap-opera *Home and Away* for about ten episodes as a surfer (again). 'I had to eat... So I played some rebel teenager who came to town and slept with Sally. Actually I think I was the first to sleep with Sally.'

Ledger knew that his performances to date had been pedestrian, to say the least – but he knew that he could improve, and he began to analyse and improve his acting skills. 'I can understand what's good and bad. I can begin to study what I'm doing wrong... I'm not really listening to them; I'm just saying the lines.'

At the same time a major new challenge appeared. Following an audition in Australia he flew to Los Angeles for a jet-lagged screen test. In spite of what he thought was a poor test, two weeks later Heath was told he was being cast as Conor in *Roar* – a big-budget television series, to be shot in Australia. His co-stars were Liza Zane (older sister of Billy Zane), John St Ryan and *Home and Away* actress Melissa George.

Set in ancient Ireland (Hibernia), Heath played Conor, the orphaned heir of one of the tribal leaders who wanders through the island fighting injustice, trying to unite the internecine druidic Celts in order to free them from Roman rule. It seemed to be the right part at the right time. 'It really fits me and I love doing it. It's a physically demanding job. Recently, we spent a whole day just doing scenes of running, fighting and riding horses through a forest.' Heath also took time to study the period. '...I took out a lot of books on Druidism and things like that, just to have a solid background. That way, when you're on the set you know what you're supposed to be doing and thinking.'

Roar failed the test of American prime-time television, being cancelled at the end of its first 13-part series. For Heath, however, *Roar* brought excellent personal reviews and his first serious relationship, with co-star Liza Zane, 18 years his senior. Once shooting was finished Heath followed her to Los Angeles. 'I fell in love and followed my heart, and that's purely what got me to LA. I figured as long as I was there, I would continue my career path.'

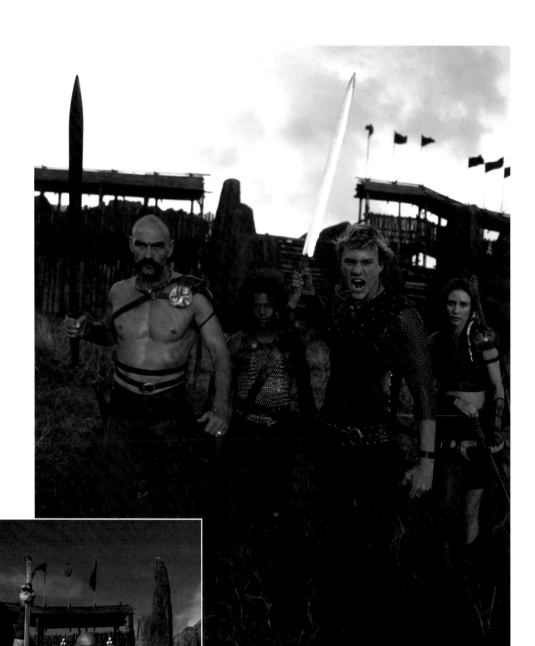

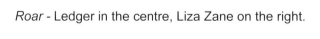

Roar - Ledger in the centre, Liza Zane on the right.

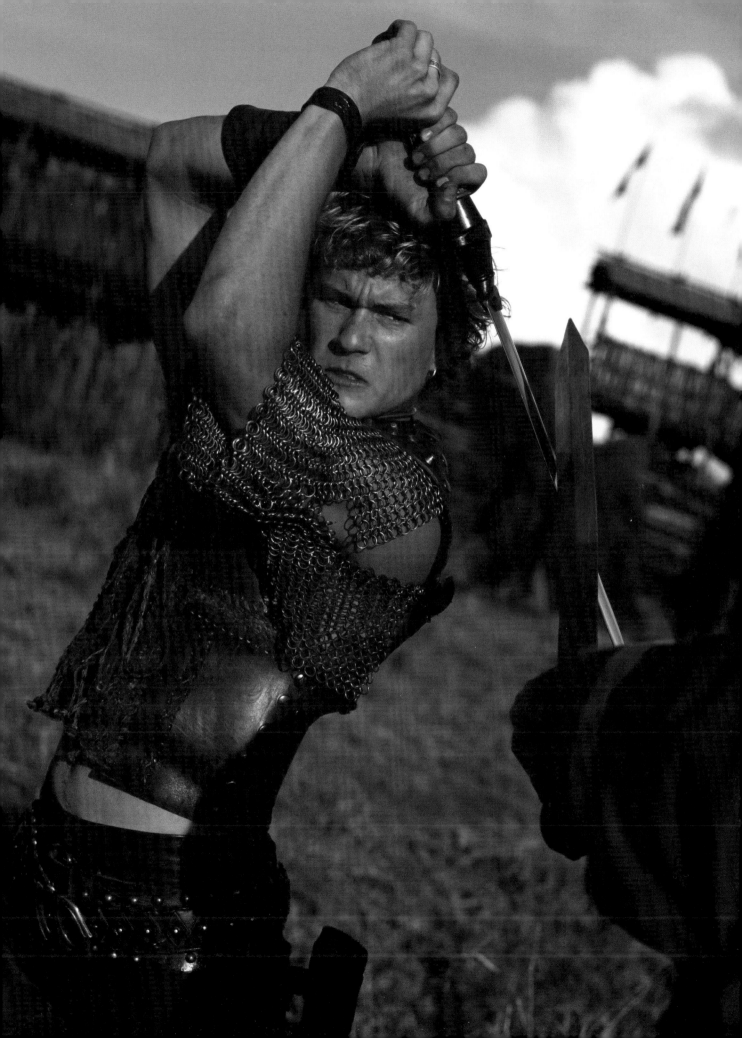

TWO:

WHO IS THIS GUY?

'I'm not good at future planning. I don't plan at all. I don't know what I'm doing tomorrow. I don't have a day planner and I don't have a diary. I completely live in the now, not in the past, not in the future'

'The now' of 1999 in Los Angeles was a good year for Heath. March saw the US premier of Touchstone Pictures' *10 Things I Hate About You*, a high-school movie which had, at its core, much of the plot of Shakespeare's *The Taming of the Shrew*. Julia Stiles plays high school outcast Kat Stafford, disliked by her classmates and teachers and ignored by her widower father. When high-school Romeo Joey wants to date Kat's sister, the beautiful and popular Bianca, he has to find a date for Kat. Enter another outcast, Patrick Verona – played by Heath Ledger – who is paid by Joey (and by Cameron, another classmate smitten with Bianca's charms) to ask Kat out. A convoluted and often hilarious working out of the plot ensues, ending at the high school prom where Patrick gets Kat and Cameron gets Bianca.

10 Things received enthusiastic reviews from the US press. The *Hollywood Reporter* described the movie as 'A high school comedy based on a William Shakespeare play – what could be hotter. ...There's also plenty of

hunkiness on display in the reluctant tamer of Kat, smooth-talking Aussie import Patrick Verona (Heath Ledger).' New York's *Village Voice* was just as enthusiastic: 'Stiles and her underage Petruchio (Australian actor Heath Ledger, as hunky as his name) are charismatic and bold enough to carry any romantic comedy.'

Strangely enough, Heath's second movie of the year was Australian. *Two Hands*, written and directed by Gregor Jordan, was shot in Sydney in 1998. Heath played the lead role of Jimmy, the strip-club worker entrusted by local villain Pando (Bryan Brown) with delivering $10,000 to a woman in Bondi. With some inevitability Jimmy loses the cash en route and spends the rest of the film trying to raise the money to avoid Pando's ire. After many twists and turns Jimmy gets the girl and Pando his just desserts. *Two Hands* was a major winner at the Australian Film Awards with nods for best film, best director and best original screenplay. Heath was nominated for best actor in a leading role but was pipped at the post by

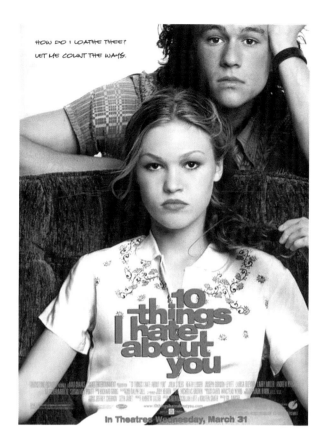

HOW DO I LOATHE THEE?
LET ME COUNT THE WAYS.

10 things I hate about you

In Theatres Wednesday, March 31

Russell Dykstra. *Two Hands* was a big success in Australia but in spite of a showing at the Sundance Festival it did not find an American market, being finally released in December 2005.

Before reaping the rewards of the worldwide success of *10 Things,* Heath had auditioned for the role of fellow Australian Mel Gibson's son in Roland Emmerich's American revolutionary war drama *The Patriot*. He'd tried for parts in other movies but was getting nowhere. Although depressed by what he considered his poor audition he was elated to hear three weeks later that he'd got the part. Dean Devlin, the film's producer said later, 'The thing about Heath is that he has the one quality that's hard to find in young actors and that's the quality of being a man.' Roland Emmerich commented, 'When he walked in the office everybody was kind of immediately straightening up and saying, "Who is this guy?" And he had quite an effect on women.'

During the first day of shooting Heath was a bag of nerves, but under the calming influence of Mel Gibson he was able to relax. 'Mel's always joking; he's very light-hearted all the time. It was never a tense shoot... we were mates and buddies, and then I guess it wasn't that hard to translate it into a father-son relationship onscreen. The film's similar to what I went through with my father, getting to an age where you feel you had your own opinions and rules in life, taking off, doing it the hard way and not listening to what he has to say.' This was reflected in the strand of the plot where Gabriel (Ledger) goes to fight against his father's wishes.

The Patriot premiered in June 2000, and, although a box office success, it received lukewarm reviews and criticism for its historical inaccuracy. Heath's performance, however, was generally praised.

Heath at the premiere of *The Patriot*, 27 June 2000

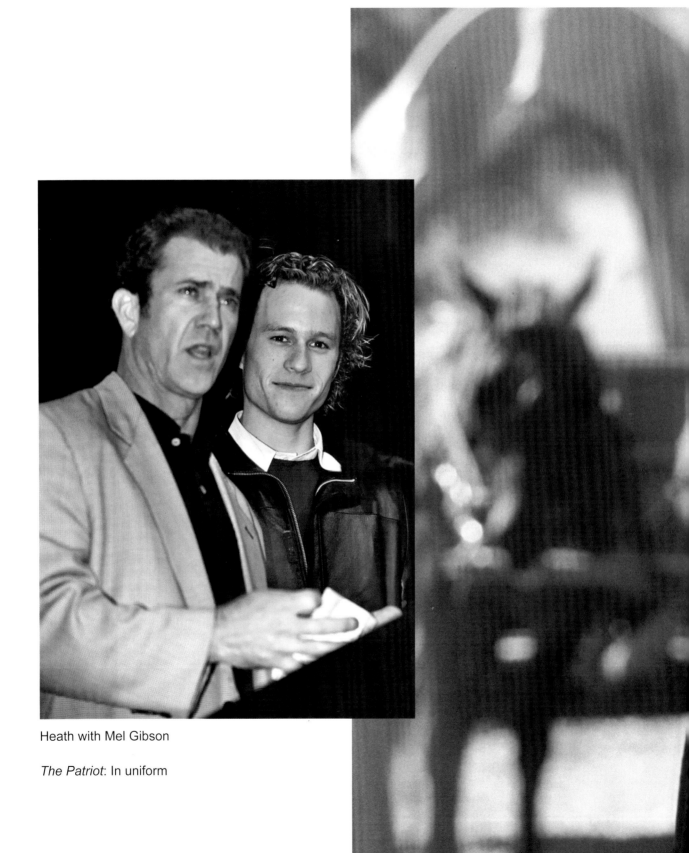

Heath with Mel Gibson

The Patriot: In uniform

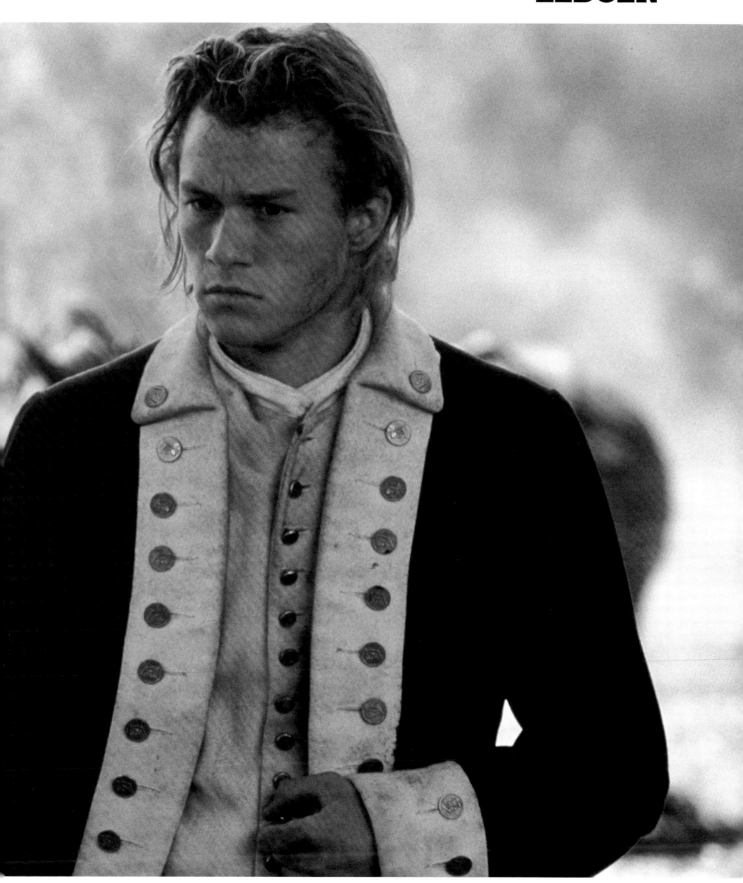

THREE:

A HUMBLE BUT AMBITIOUS SQUIRE

'I love acting. Oh God, I love it. But all this fame and all this bullshit attention.
I'm not supernatural. I've done nothing extremely special to deserve the position.
It happens every couple of years, and it's happened to hundreds of people before me.'

Before *The Patriot* opened Heath was heavily involved in a new project, *A Knight's Tale*. For the first time he was the 'star' of a movie. At the age of 21 he was going to have to carry a $50 million blockbuster. *A Knight's Tale* was a very individual take on a medieval jousting adventure written and directed by Brian Helgeland (winner of an Oscar for his brilliant script for *L.A. Confidential*). Heath plays William Thatcher, a young squire who joins the jousting circuit after the death of his knight. Under an assumed name he travels around Europe with his two fellow squires and Geoffrey Chaucer, his herald (filling in time before writing *The Canterbury Tales*).

Thatcher falls in love with Jocelyn (played by Shannyn Sossamon) and has a continuing rivalry with Rufus Sewell's villainous Count Adhemar of Anjou. Heath saw the film primarily as fun: 'When I read the first page of the script and it said the film opens with the song "We Will Rock You", I thought to myself "Oh God, what are they trying for here?"...But the more

I read on, I began to realise the beauty of it. It gave licence and room to play without being restricted by historical facts....We're making a movie, just a movie, a fairytale.'

It was during his four-month stay in Prague while shooting *A Knight's Tale* that Heath met actress Heather Graham, who was in the Czech capital filming *From Hell* with Johnny Depp. They were soon an 'item', an interesting couple – Heath from a laid-back Australian background and Heather (ten years his senior) from a strict mid-western family.

The whole of the shoot was a giant 'boys' night out'. Helgeland assembled the cast four weeks before the start of principal photography and, according to Heath, 'Then he got us pissed for a month... But that was a smart move because this movie is really about friendship. By the end of that month we really, really liked each other.'

When the promotion of the film started, Heath was freaked out to discover that the poster consisted of a close-up of his face – he was the star, like it or not. 'When I saw the

poster for the movie... I got really nervous. I think I started shaking. The film is an ensemble piece and there's just my great big mug.... It was like... fuck I've done all this work, but ultimately guys are making decisions that could either really make or break my career.... I'm doing what I've always done – being an actor. Now I'm being made into a "star", a product, and it's out of my control.'

Fortunately the critical and box office response to the film was generally good. The London *Guardian* newspaper's film critic's comments sum up reactions to the movie: 'This is a deeply silly film.... It has the silliest lines, the silliest set-pieces, the silliest performances of anything I can ever remember seeing. And yet I came out of the cinema with a great big grin on my face.... Hollywood's hunk of the moment, Heath Ledger plays William Thatcher... a humble but ambitious squire.... With his tousled beach-blond hair, Ledger is actually a pretty good approximation of Chaucer's Squire: "A lovyere and a lusty bacheler".'

After the success of *A Knight's Tale* Heath was offered, and rejected, the lead role in *Spider-Man*. He still didn't feel secure in his acting skills. He said later: 'I hadn't at that point, and still haven't, secured my position as an actor who can act.... It would have been a lot harder to go from being Spider-Man on every poster to getting nitty-gritty little roles on independent movies with really good stories, good characters, good writing... Whereas if you can prove yourself and do the hard yards and pump out some performance, and create something solid in you first and foremost then you can afford to do that.'

With *A Knight's Tale* completed Heath moved from chilly Prague to Morocco to start

work on *The Four Feathers* in the Autumn of 2000. The film, directed by Shekhar Kapur, was the seventh movie version of the novel of the same name by A E W Mason. The tale of honour, love, friendship and redemption set in Victorian England and war-torn Sudan had had an irresistible attraction for filmmakers over many years.

Heath was cast as Harry Feversham, a young British army officer who resigns his commission rather than fight in the Sudan. He is accused of cowardice by three fellow-officers and his fiancée who each present him with a white feather. Feversham travels to the Sudan, scene of a war between the British and Muslim rebels who are attempting to end the colonisation of their country. Working under cover, Feversham is able to rescue his three former friends and so redeems his good name.

The four-month shoot was much more arduous than the relaxed regime of *A Knight's Tale*. There were some very arduous action sequences and the director was very demanding: 'When you work with Shekhar Kapur it's a real commitment. I learnt so much from him but he took out so much. You have to devote yourself to him and if you do that, he will take you somewhere special. He's an extremely passionate film-maker. In Prague, everyone had their own little apartment and we would meet around the corner for coffee... In Morocco there was one hotel in the place where we were shooting and that was it... That was my life for four months – in my hotel room by myself and there was nothing else beyond that. It was crazy.'

After working on three major films over 18 months, Heath decided on some time out. So, in April 2001 Heath and Heather set out for Perth, his home town. It was on this trip that

HEATH LEDGER

Heath began to see what the true cost of being a star was. 'I was really unprepared for it. Of all the places you wish to just stay the same, it's your home. You want that to be the same and it wasn't. I couldn't do anything. It makes front page news if you eat fettuccine on Tuesday. I came straight off working 18 months and all this was bubbling up while I was working, so when I arrived – bang! – it had all changed.'

Heath and Heather returned to Los Angeles and she joined him at the West Coast premier of *A Knight's Tale* on 11 May 2001. Shortly afterwards the couple parted, after an eight-month relationship.

As the lusty young Squire on *A Knight's Tale*

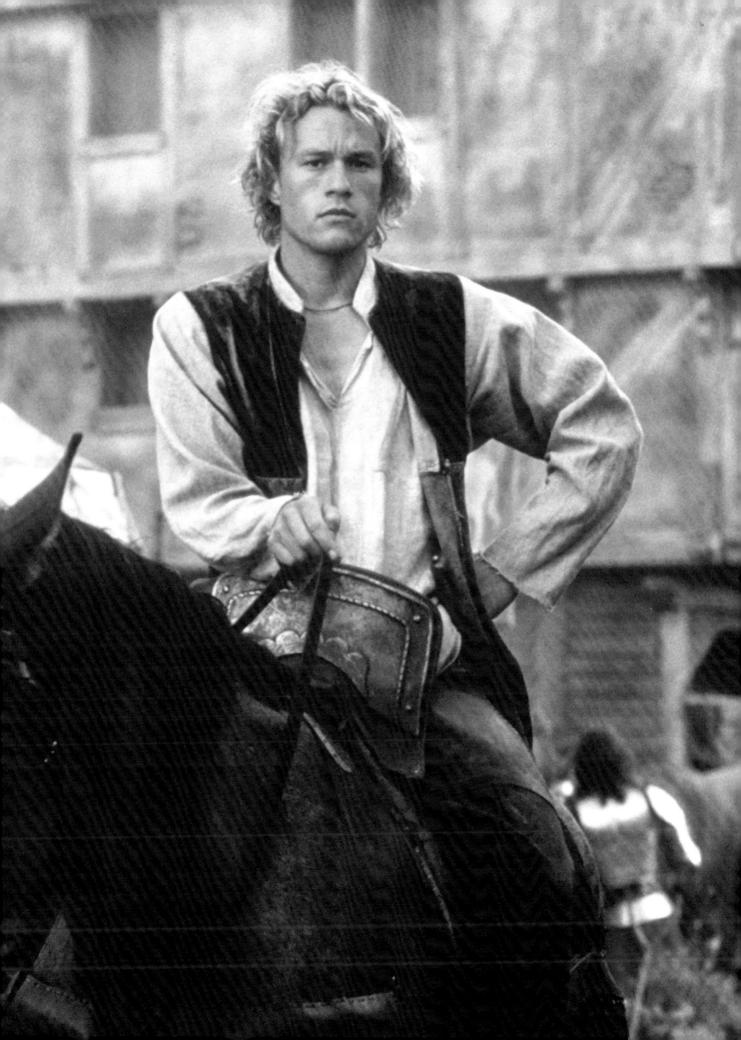

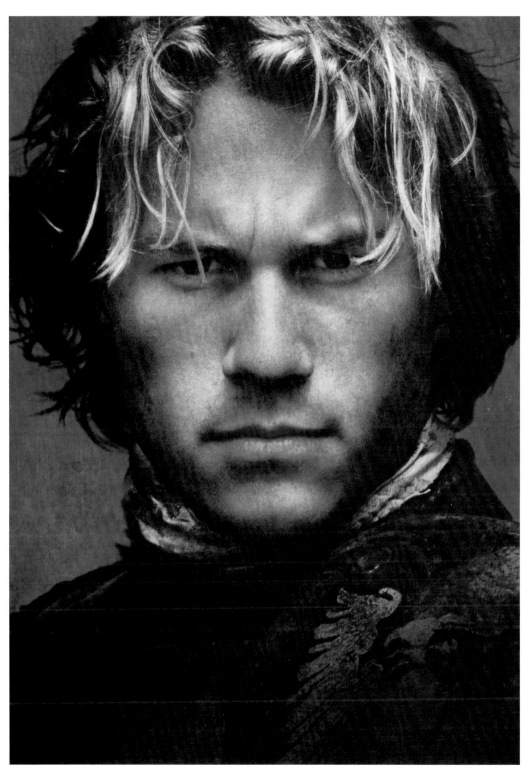

Poster image for *A Knight's Tale*

The Four Feathers.
Harry Feversham
(Heath Ledger)
watches from
the crowd as his
comrades march
off to war.

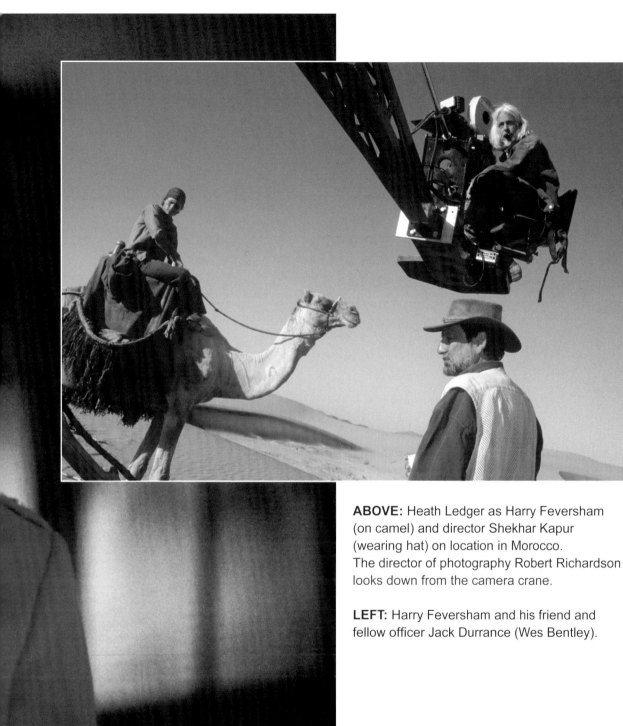

ABOVE: Heath Ledger as Harry Feversham (on camel) and director Shekhar Kapur (wearing hat) on location in Morocco. The director of photography Robert Richardson looks down from the camera crane.

LEFT: Harry Feversham and his friend and fellow officer Jack Durrance (Wes Bentley).

HEATH
LEDGER

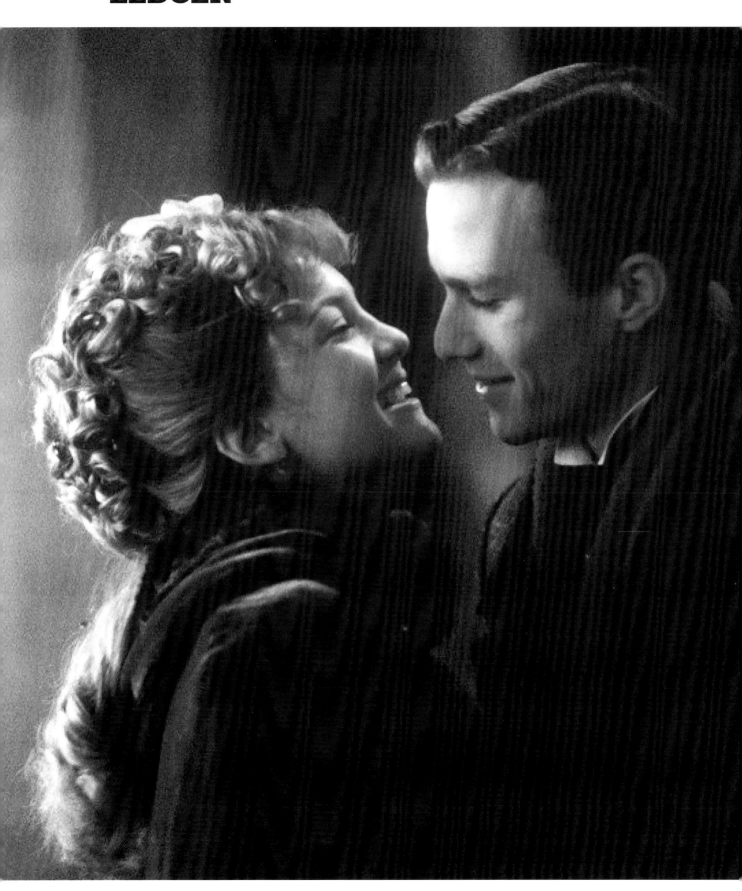

Kate Hudson (Ethne) and Heath Ledger (Harry)

'No one in their right mind could call you a coward.
Especially not your friends. If there's been some
kind of misunderstanding you have to clear it out.'

FOUR:
CHOICES

'I have never had great expectations of my performance or of a film. I try not to think about the outcome. If you look that far ahead, it sort of taints your choices as an actor. I try as hard as I can to believe that no one is ever going to see it and that it's not even a movie. Then you can allow yourself to bare more. Then, once a project is done, I tend to forget about it until it comes out.'

After working on three big-budget action films in a row, Heath's career took a change in direction when he was cast as the prison warder son (Sonny) of Billy Bob Thornton (Hank) in *Monster's Ball*. Heath's character is a third-generation prison guard who works in the same prison as his embittered bullying father. Father and son are assigned to escort a prisoner to the execution chamber. The younger man finds the event so disturbing that he is physically sick. Hank humiliates Sonny for this perceived weakness and hits him. These events lead Sonny to confront his father in the living room of their home, 'You hate me don't you?' His father calmly confirms that he does and always has. Sonny responds 'Well, I always loved you' before shooting himself. This cathartic event causes Hank to quit his job, and as the result of a series of events starts a relationship with the widow of the executed man (Halle Berry). Berry was to win an Oscar in 2002 for her performance.

Monster's Ball was a complete contrast to Heath's previous three films. It was shot in five weeks (some scenes were shot in the execution chamber at the Louisiana State Prison in Angola) with a budget of $4 million. Ledger was also in a supporting role. Nevertheless his commitment to the part was absolute. Billy Bob Thornton recalled, 'When we were filming the "warden" (played by co-writer Will Rokos) almost had to step in because he thought it was real. Heath's a tough kid.'

Director Marc Forster praised Heath's approach to his role. The actor had come to the part at the last minute: 'He's very disciplined and takes it very seriously.... Heath at the time was something like 22 and I thought, "He's incredible. He's so smart and so intuitive and so observant, and he really understands the part and the character."'

The film (released in December 2001) received excellent reviews, as did Heath's performance. He was also praised for his performance in *The Four Feathers*, although the film bombed critically and at the box office.

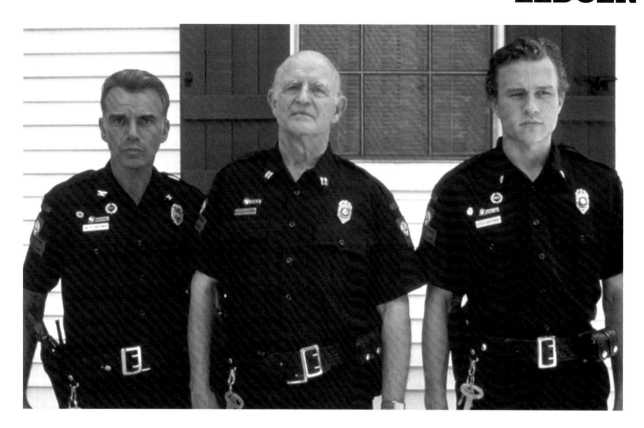

Heath's next project was to be a complete disaster. It probably seemed like a great idea, reuniting much of the cast of *A Knight's Tale* with director Brian Helgeland for a supernatural thriller called *The Sin Eaters* – released as *The Order*. A review from the *Chicago Sun-Times* sums up this train-wreck of a movie: '...I have nothing good to say about *The Order*. I probably should have run screaming when the film's distributor, 20th Century Fox, refused to hold press screenings – movie studio speak for "Our movie reeks and we don't want anyone to know it."...in Helgeland's hands *The Order* is little more than a series of random plot points and religious babble mixed together and spat onto the screen in no particular order. We have characters falling in love without explanation or chemistry; we have people popping up in "sinister" plots that seem irrelevant to the story, as we know it. The worst part of all, though, is that none of these things matter. Because,

frankly, we don't care.' The *New York Daily News* said: '20th Century Fox didn't screen this movie for critics, a sure sign that vile sins have been committed. Sure enough, Ledger as Alex Bernier is a big loser in this low-energy crypto-thriller.'

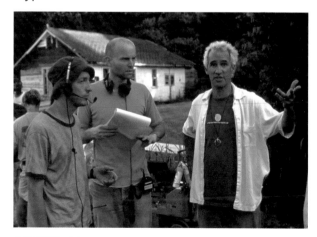

ABOVE: *Monster's Ball* Director Marc Forster

TOP: Three generations in *Monster's Ball*: Billy Bob Thornton (Hank Grotowski), Peter Boyle (Buck Grotowski) and Heath Ledger (Sonny Grotowski).

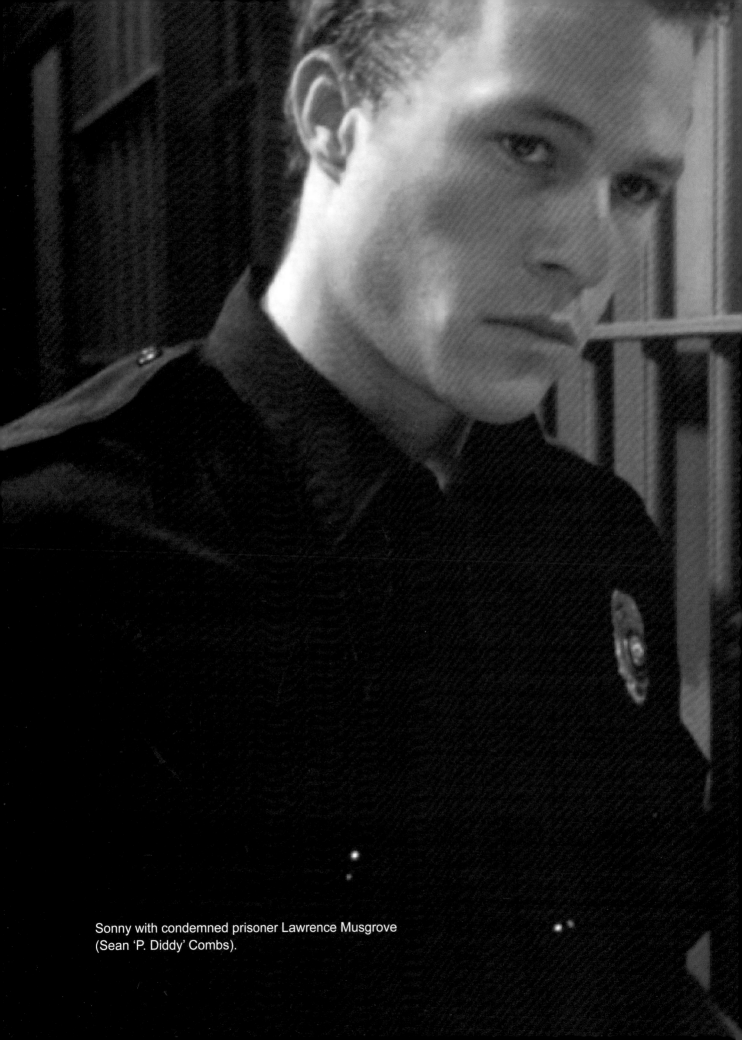

Sonny with condemned prisoner Lawrence Musgrove
(Sean 'P. Diddy' Combs).

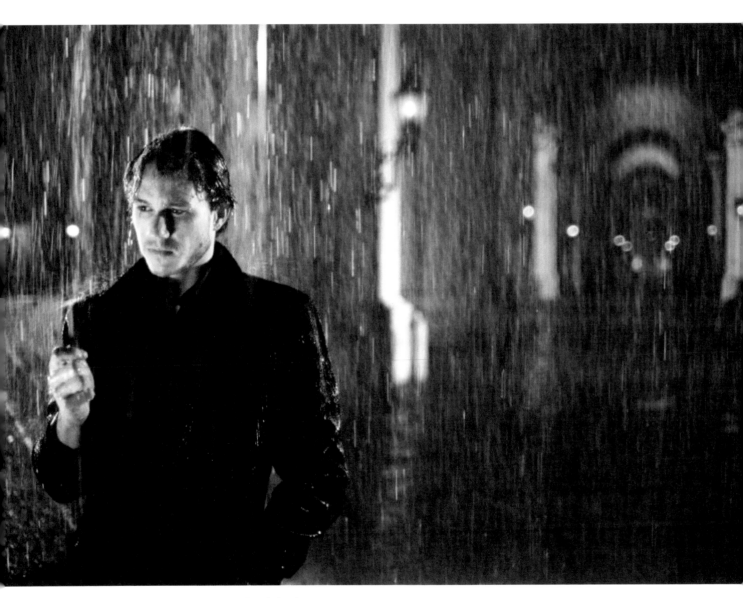

It never rains but it pours. Heath Ledger
as young priest Alex Bernier in *The Order*.

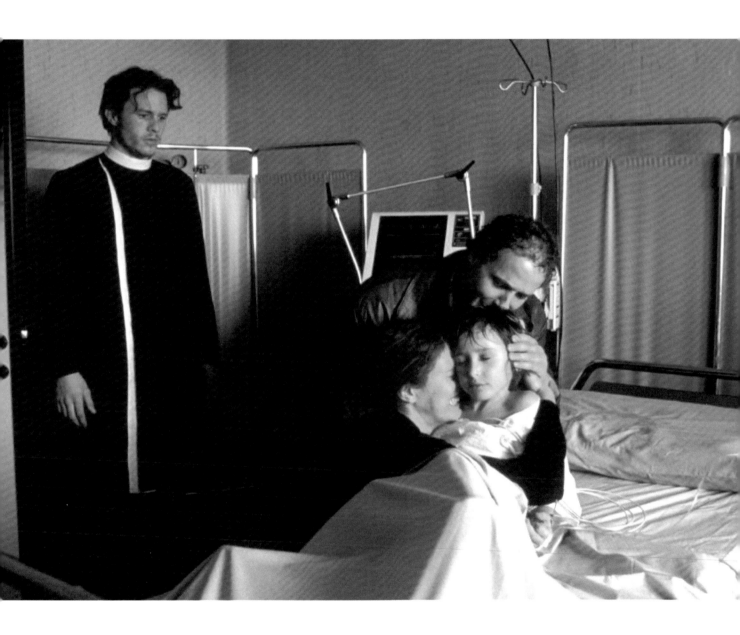

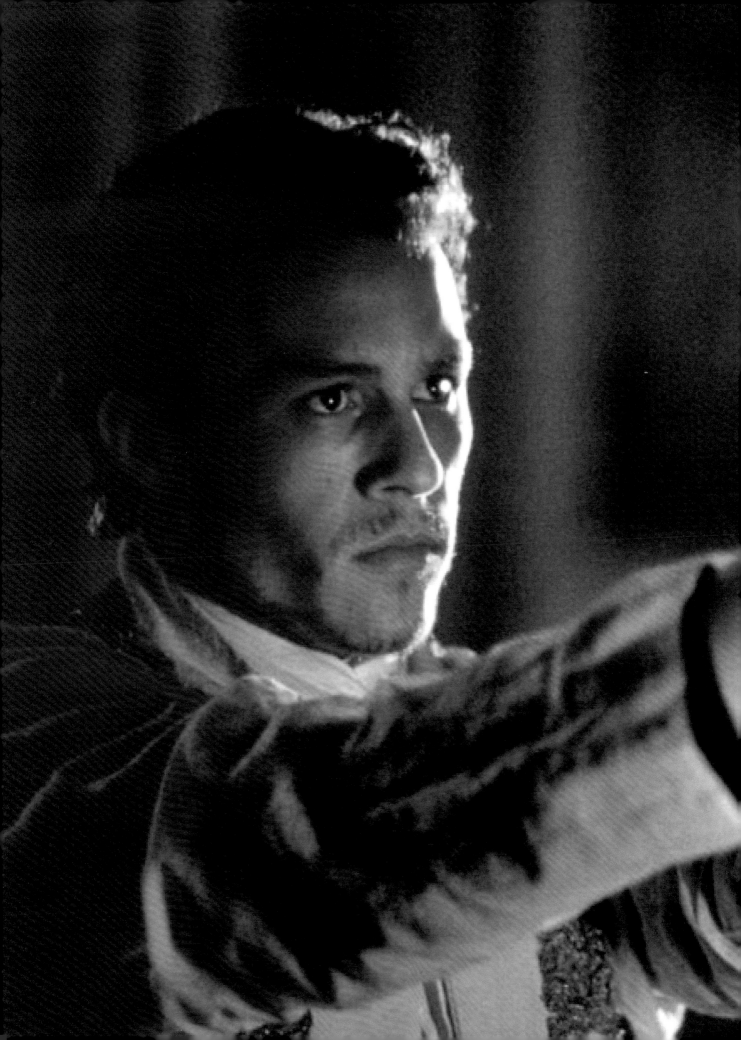

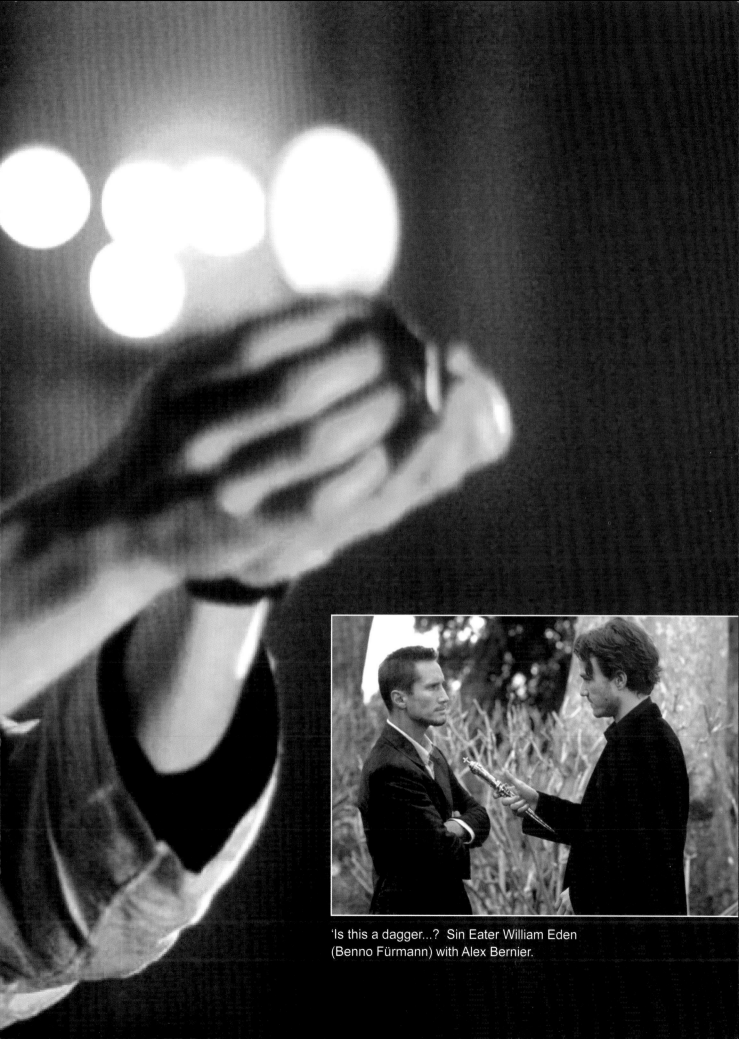

'Is this a dagger...? Sin Eater William Eden (Benno Fürmann) with Alex Bernier.

FIVE:

INSTINCTS

'I just like interesting people. When we worked on Ned Kelly, Naomi and I definitely had a connection but it probably happened off screen rather than on, because when you're working there's nothing sexy about 50 people standing around and staring at you.'

The Order had finally limped into cinemas in late 2003, although it had been completed in 2002. By summer of that year Heath was back in Australia filming *Ned Kelly*. The story of the nineteenth-century Kelly brothers and the Ned Kelly Gang was a powerful part of Australian folklore – so much so that there had already been eight films about the outlaw band (the first in 1906), including the much-derided 1970 version starring Mick Jagger as Ned. With a cast including Rachel Griffiths, Naomi Watts, Russell Dykstra and Orlando Bloom and director Gregor Jordan (who had previously directed Heath's film *Two Hands*) this was to be a serious attempt to come to terms with the Kelly legend. Director Jordan was quoted as saying that Heath was currently the only actor who could play the role of Ned Kelly.

For his part Heath was very committed to the role. 'I'm an Australian, so clearly it is a dream role. It was the best opportunity I have had to sink my teeth into a part. I've looked up to him since I was a kid. I remember thinking that I'd

love to play him. He represents a lot to me, such as dignity and sticking by your family and mates. I'm totally on Ned's side because what the cops did to him was terrible and he had a just cause to stand up against them.'

Heath undertook a considerable amount of research into the role including Kelly's famous 'Jerilderie letter' – an 8000 word document dictated to fellow gang member Joe Byrne, giving Kelly's version of the events leading up to the deaths of three policemen at Stringybark Creek, his outrage at the treatment of his family, and his desire for justice. Ledger commented on 'just how passionate he was in there and so definite, so precise, and how sure he was about his cause… I read up on him and I looked into his eyes. There's a portrait of him two days before he was hanged – it's all in his eyes: he is very dignified, he is very proud and that was enough. I just trusted my own instinct and went for it. I'll certainly take a piece of Ned with me; he's certainly going to be carried around in my heart and mind for a long time. It's given me the courage to stand up and be

true to what I believe in.'

Naomi Watts, fresh from her success in *Mulholland Drive* and *The Ring* arrived some weeks into the shoot to film her short role as Julia Cook, a squatter's wife. Watts had been born in England but raised in Australia and, like Heath, was a graduate from *Home and Away*. Although Watts' shooting schedule was only six days, it was sufficient time for her and Heath to start a romance.

The world premier of *Ned Kelly* took place in Melbourne on 22 March 2003, with Heath and Naomi attending as a couple. The film received mixed reviews – the consensus being that the complexities of the story had been toned down to make the film acceptable to an American audience. There was praise for Heath's performance – a reviewer for the Australian Broadcasting Corporation wrote: '…some of the best sequences are due in part to Heath Ledger's internal dialogue voiceover, giving an inner life to the musings of a troubled anti-hero.'

For the moment Heath and Naomi were very publicly a couple, joining an anti-Iraq war demonstration in Melbourne, sharing a house in Los Angeles, and attending Hollywood functions. They were also busy working actors. In 2003 Naomi started work on *21 Grams,* working with Sean Penn and Benicio del Toro, while Heath was off to Prague again, this time for a role in Terry Gilliam's *The Brothers Grimm*. Although the couple split temporarily in September, they were together again for the Australian premier of *21 Grams* in January 2004.

Director Terry Gilliam's take on the story of the two nineteenth-century academic brothers was characteristically different, transforming the learned Wilhelm and Jakob into conmen

Jake (Heath) and Will (Matt Damon), who make their living driving out 'evil creatures' which are, in fact, from their own imaginings. Filming was marked by a series of rows between Gilliam and producers Bob and Harvey Weinstein. They had already vetoed Gilliam's choice of leading lady. Then there was the war of Matt Damon's nose. Gilliam wanted him to wear a prosthetic nose to alter his appearance – the Weinsteins disagreed. The issue became so heated that the producers threatened to close the film down if Gilliam insisted on the prosthesis. Result – no prosthesis. Finally, five weeks into the shoot, Bob Weinstein fired Gilliam's director of photography Nicola Pecorini for 'shooting too slowly'. Gilliam was incandescent but agreed to complete the movie.

In spite of the tensions between director and producers Heath enjoyed himself. 'There was never a dull moment on the set… Everything inside me goes at a hundred miles an hour. Usually when I'm working it's "OK, I'm going to centre myself." But Terry says, "I love all that stuff you do. Just go for it." So he's provoked a lot of my stupidity…. He's an incredible, dignified, intellectual visualist and as mad as a mongoose.'

Once shooting was finished there was a hiatus as Gilliam took time out to cool down. He was to make another film, *Tidelands,* before completing *The Brothers Grimm* for release in the summer of 2005, two years after Heath had finished filming.

In Spring 2004 Heath began work on *Lords of Dogtown*, a film set in 1970s southern California, about the genesis of modern skateboarding (based on an earlier documentary *Dogtown and Z-Boys*). Social outsider Skip Engleblom owns a surf shop

HEATH LEDGER

in Santa Monica, California or 'Dogtown'. He recruits a team of local boys to form a skateboarding team – the 'Z- Boys', who turn skateboarding into a worldwide phenomenon. Directed by Catherine Hardwicke, whose first movie the teenage angst-fest *Thirteen* (2003) had been well received, Heath enjoyed shooting close to home and flexing his surfing and skateboarding skills.

Lords of Dogtown was the beginning of a busy year but, for various reasons, a Heath Ledger film had not been released for some time. However, Heath took this as a positive: 'I sort of took my career and destroyed it…. I had to destroy it in order to rebuild it because I was getting pigeonholed. People weren't giving me a chance to do anything other than be the blond-haired bimbo and it was starting to bore me. I couldn't have spent the rest of my life following the paths that were being presented to me, so I had to start creating some for myself. This year is finally the time that it's coming together for me in terms of testing myself and what I can do: it's taken a while but it looks like doors are opening again, and *Lords of Dogtown* is a good beginning.'

In April 2004 Naomi Watts and Heath split for the final time.

Poster image for *Ned Kelly*

RIGHT: With Naomi, at the press conference for *Ned Kelly*

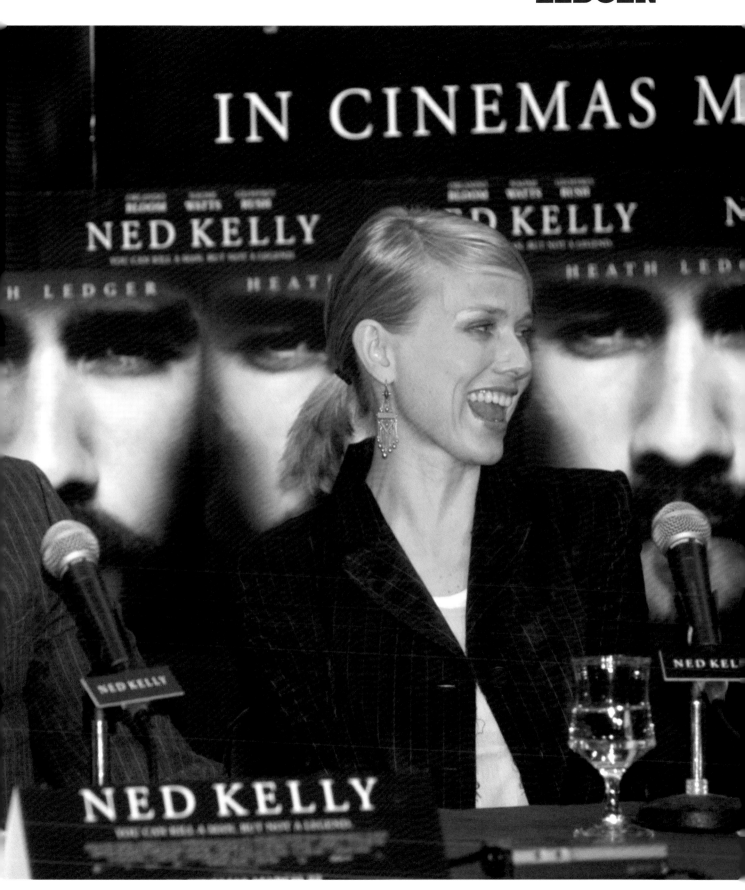

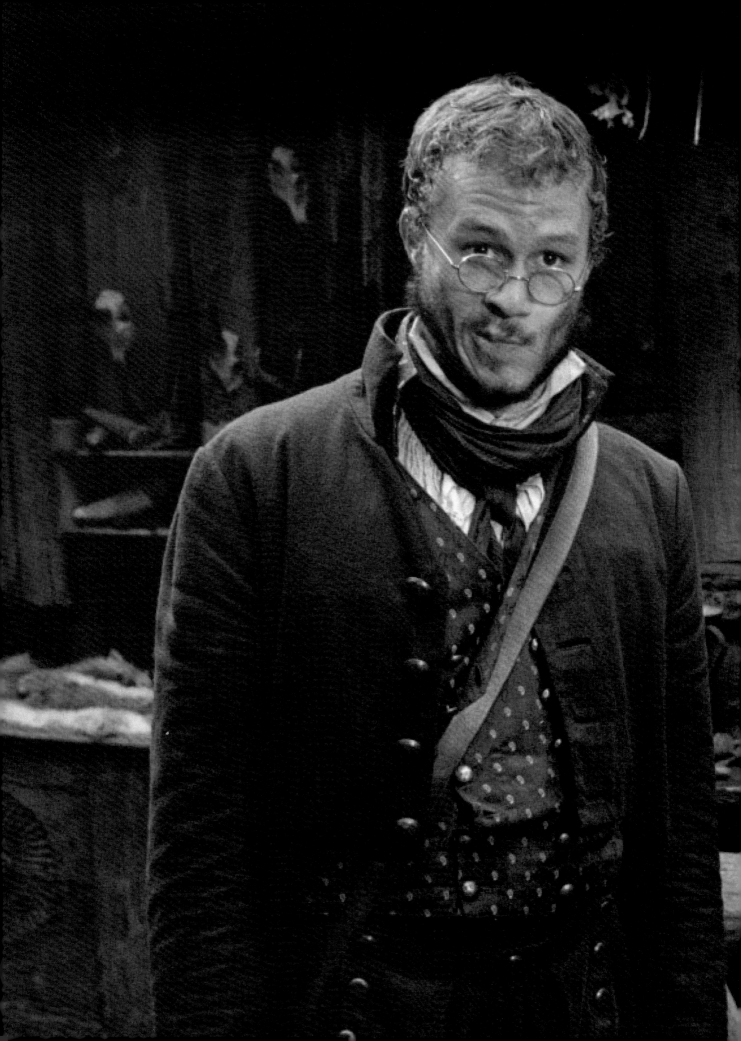

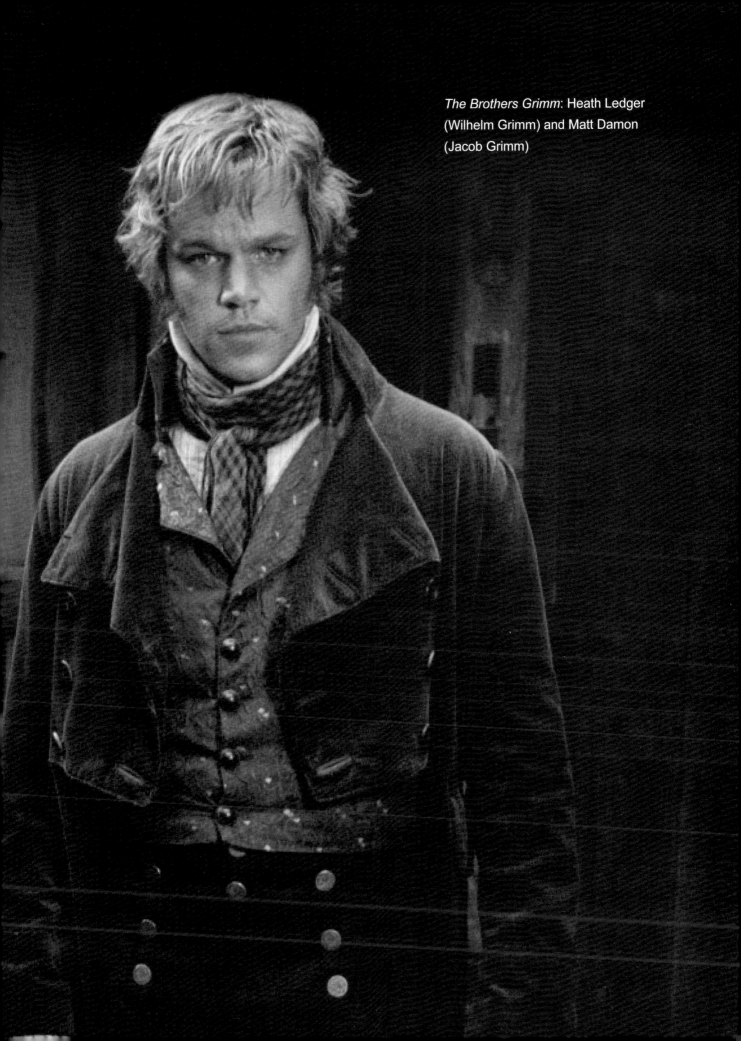

The Brothers Grimm: Heath Ledger (Wilhelm Grimm) and Matt Damon (Jacob Grimm)

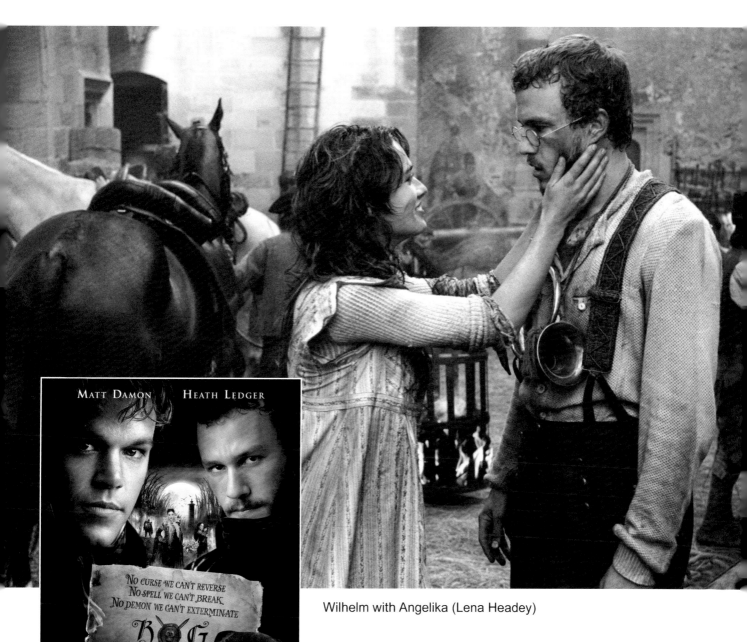

Wilhelm with Angelika (Lena Headey)

The Brothers Grimm presented a very individual take on
the famous collectors of folklore and fairytales…

Heath as Jacob Grimm. 'Never a dull moment...'

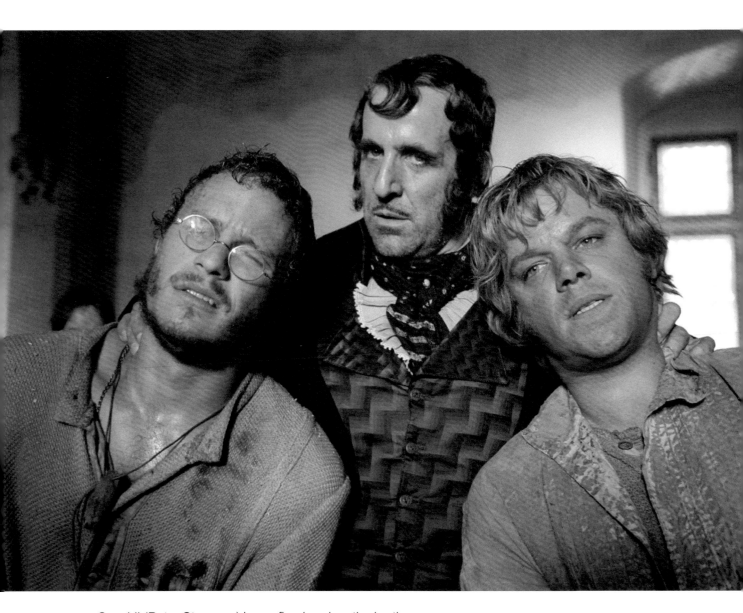

Cavaldi (Peter Stormare) has a firm hand on the brothers.

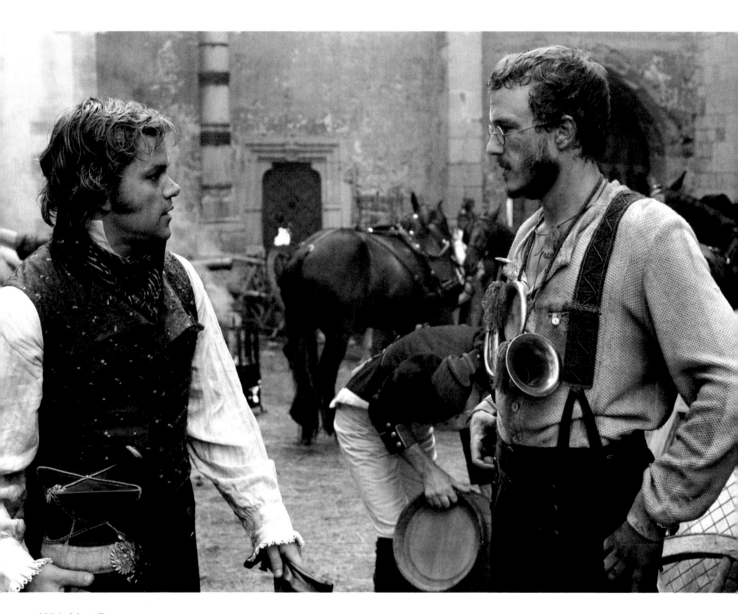

With Matt Damon

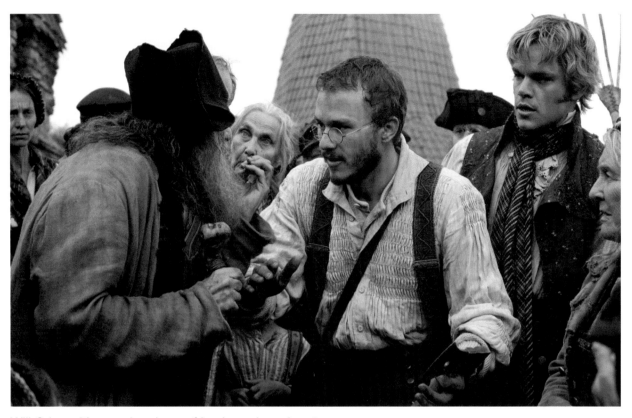

Will Grimm: You, my handsome friend, you have heart.

Jacob Grimm: And you, Will, have enough bullshit to fill the Palace of Versailles.

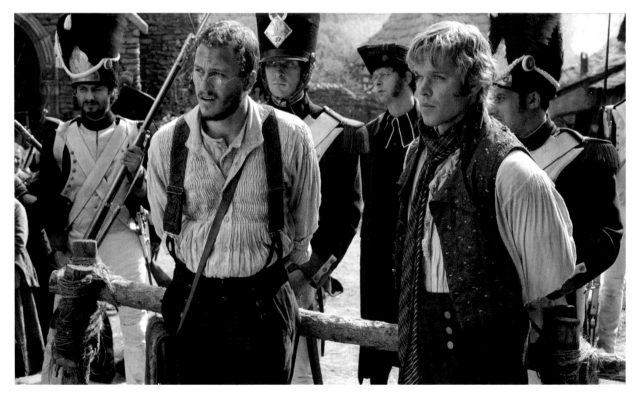

Will Grimm: This isn't a fairy tale. They are not coming back!

Jacob Grimm: This is not your world, Will!

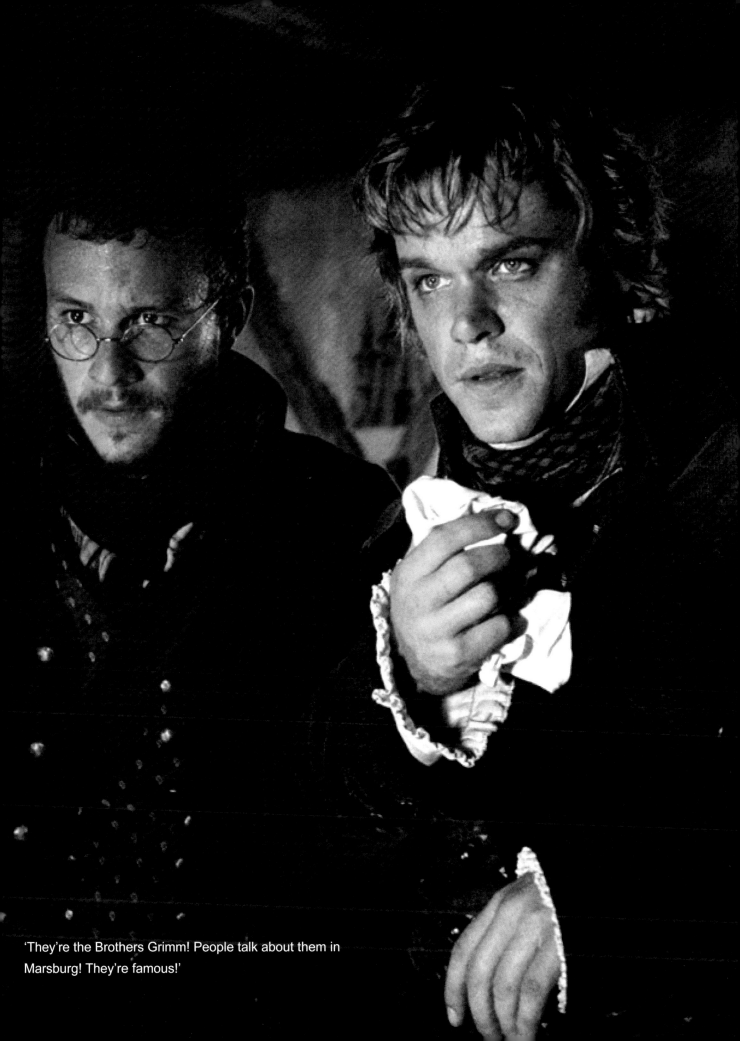

'They're the Brothers Grimm! People talk about them in
Marsburg! They're famous!'

Director Terry Gilliam
discusses a scene from
The Brothers Grimm
with Matt Damon and
Heath Ledger.

With Matt Damon and
Terry Gilliam. But this
was not always such a
harmonious set…

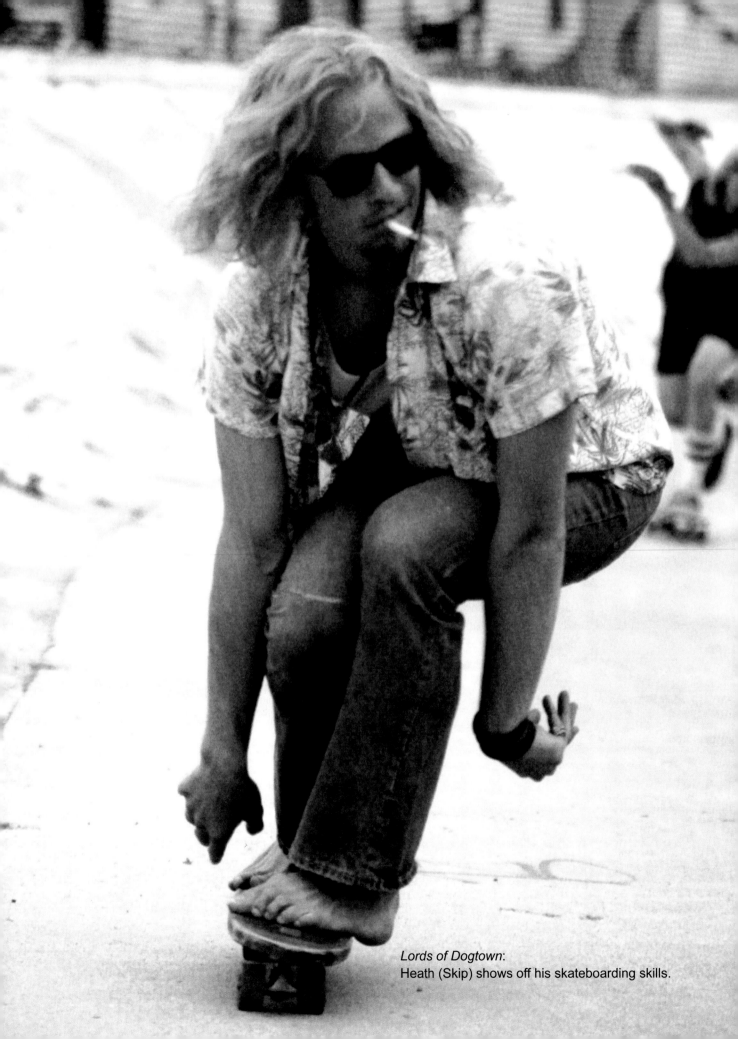

Lords of Dogtown:
Heath (Skip) shows off his skateboarding skills.

Skip and the Z-Boys

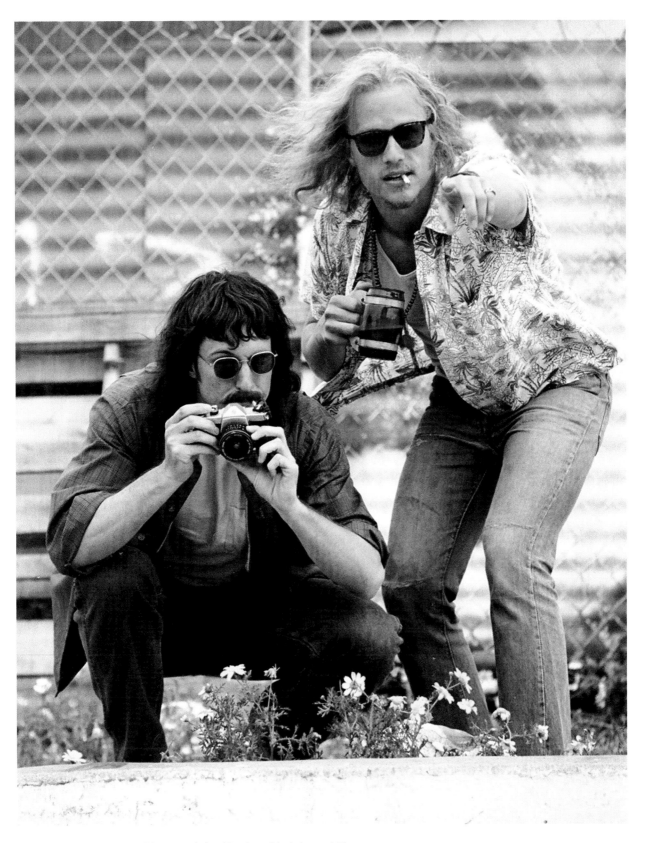

'Yeah, this is Skip Engblom and the Zephyr Skateboard Team.
Here's our entry fees. Now where's our trophies?'

'Yeah, get a haircut, man.'

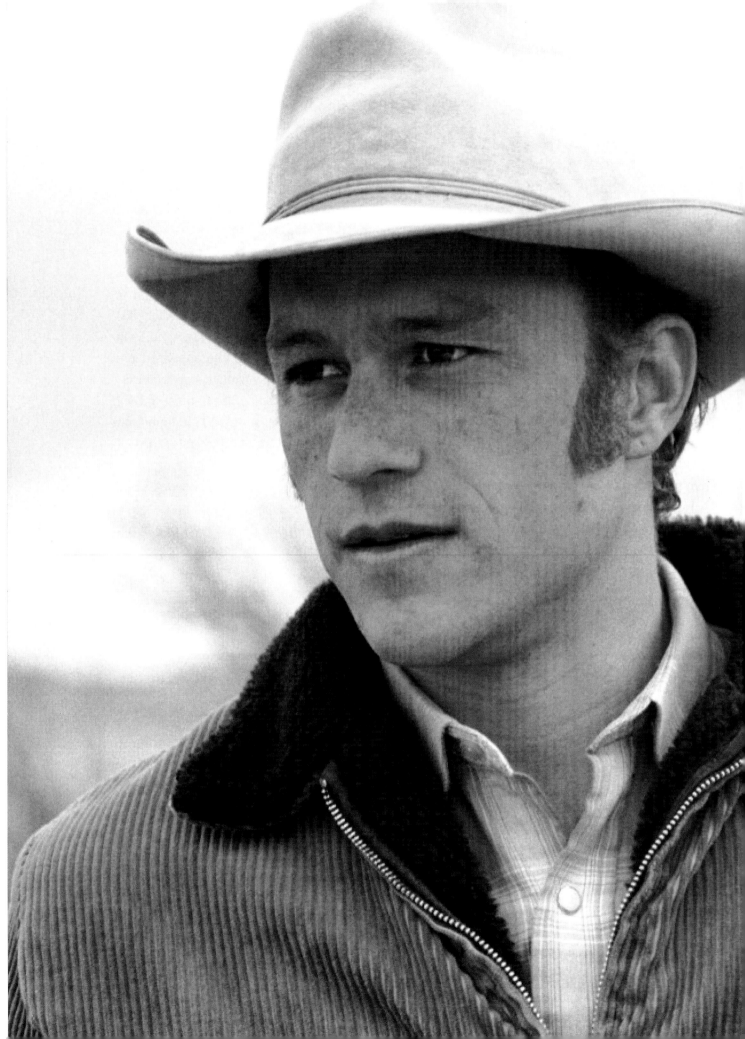

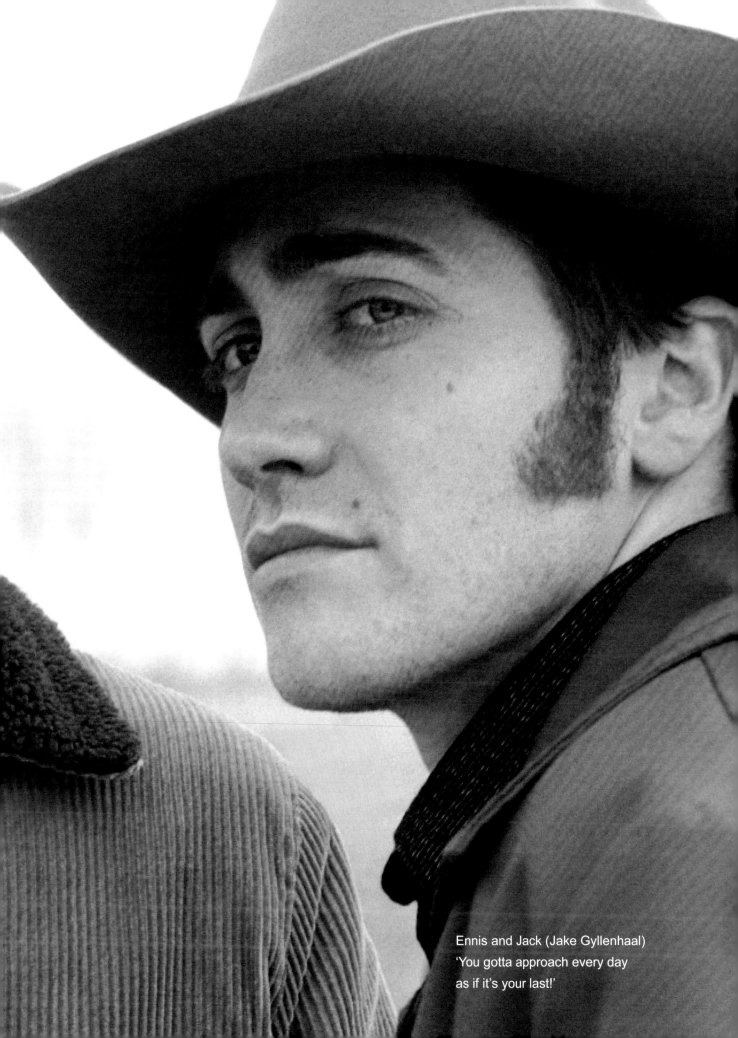

Ennis and Jack (Jake Gyllenhaal)
'You gotta approach every day
as if it's your last!'

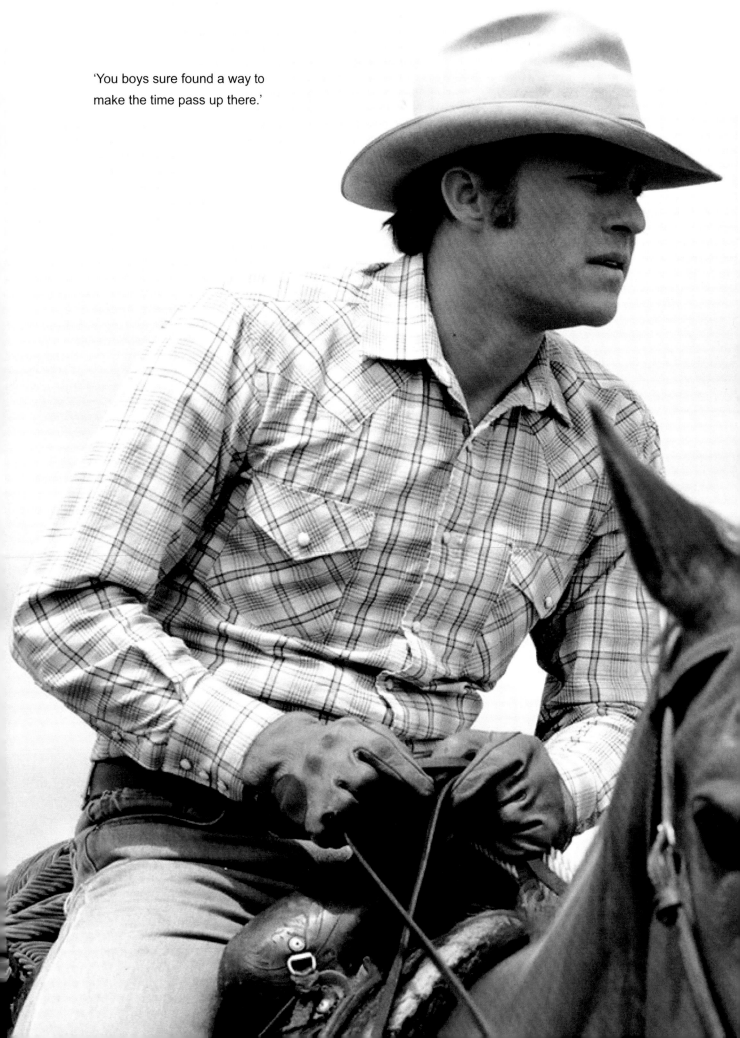

'You boys sure found a way to
make the time pass up there.'

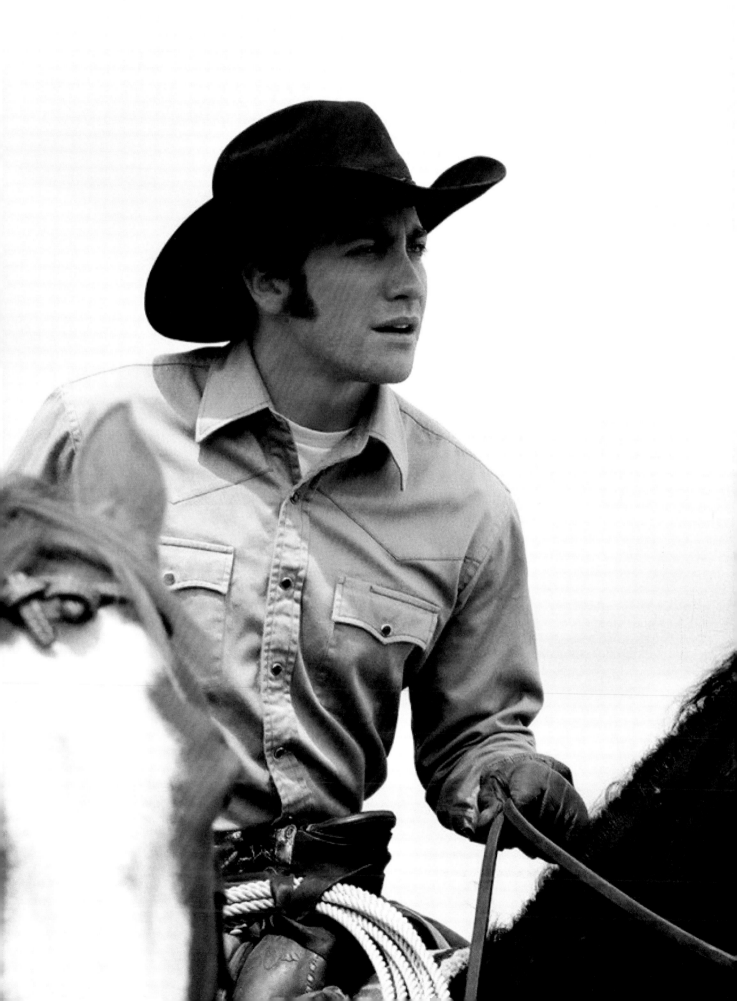

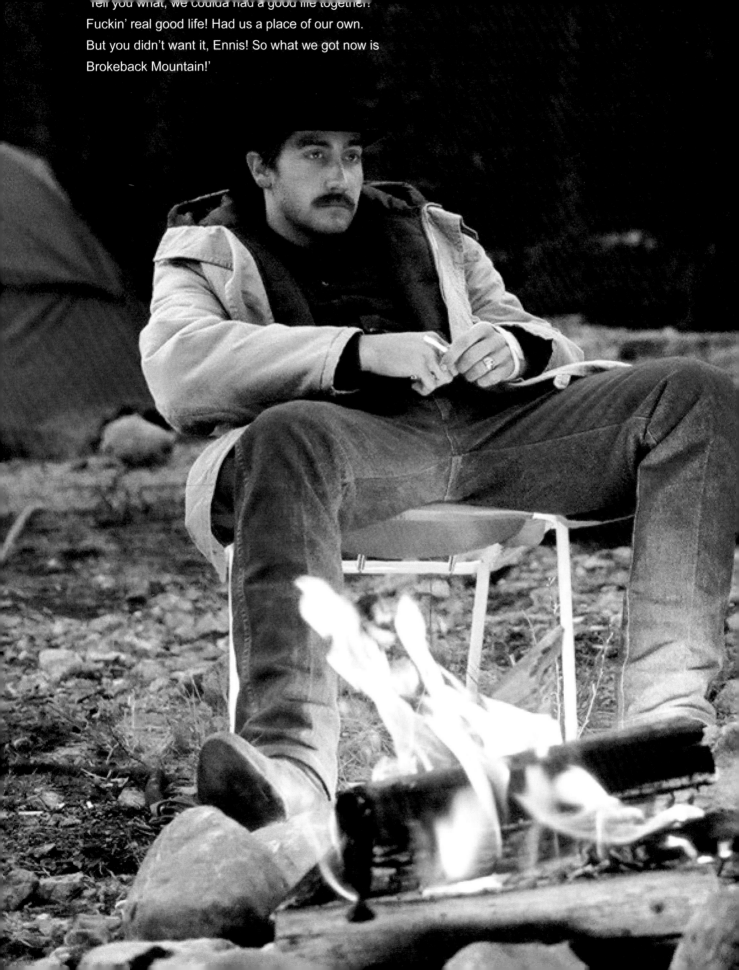

'Tell you what, we coulda had a good life together!
Fuckin' real good life! Had us a place of our own.
But you didn't want it, Ennis! So what we got now is
Brokeback Mountain!'

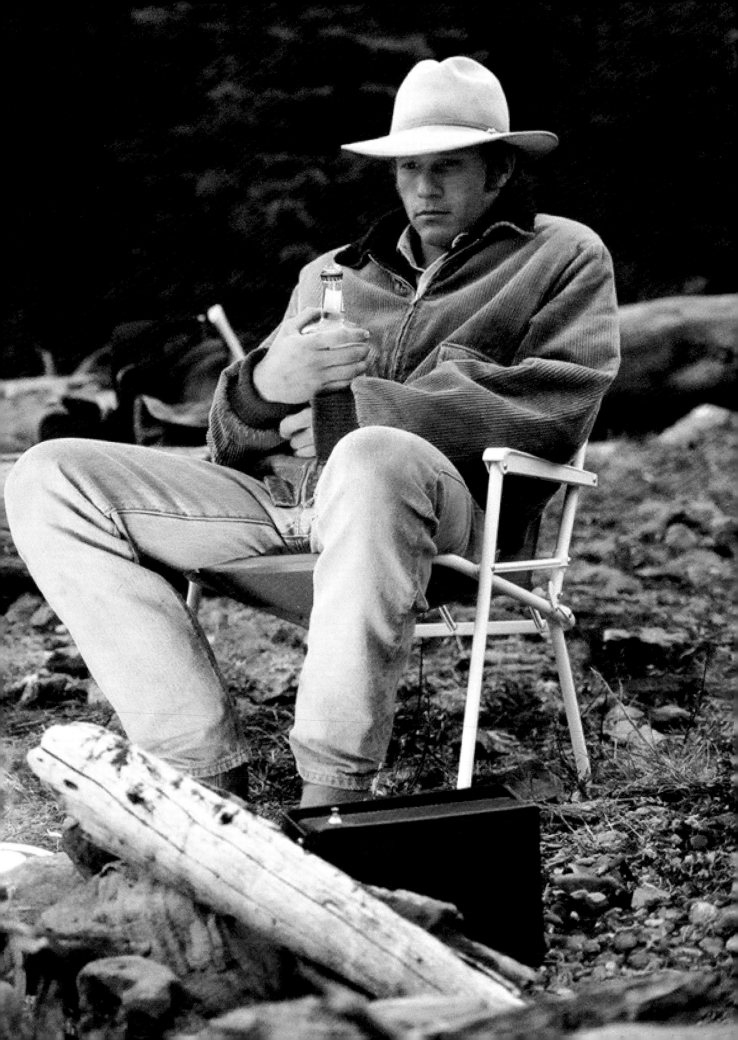

HEATH
LEDGER

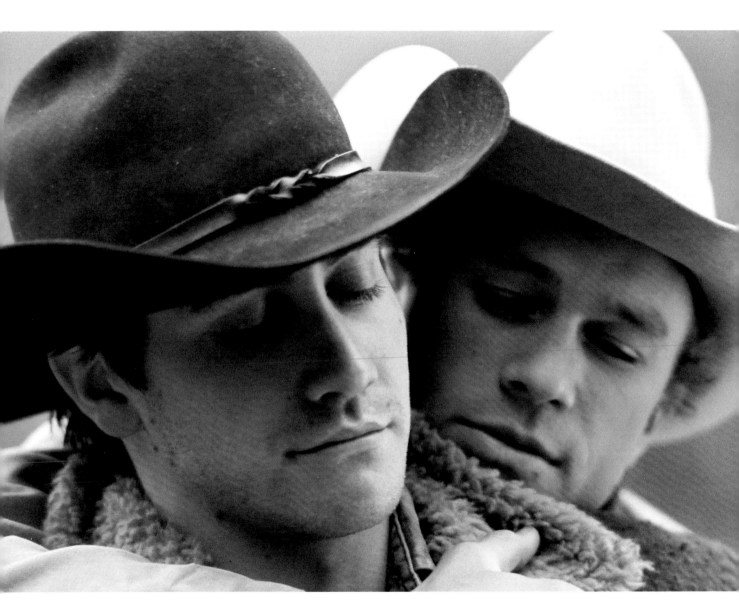

Happier days

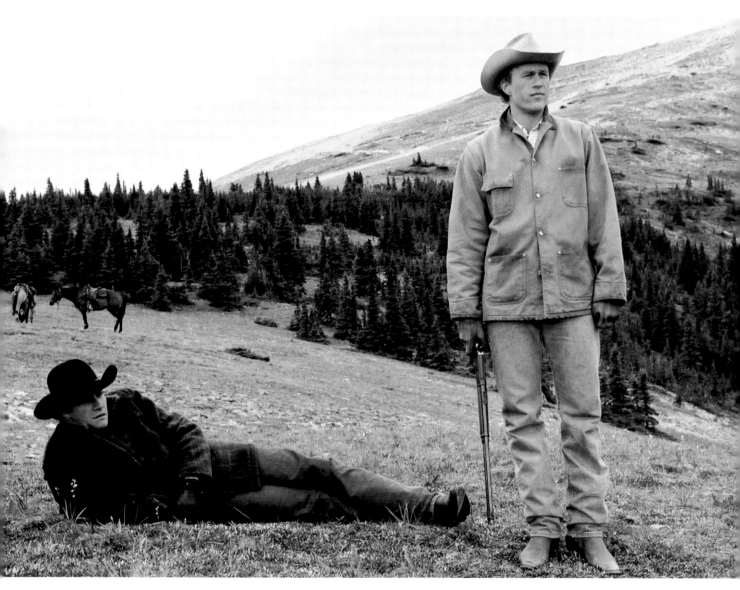

High up on Brokeback Mountain

'Ya know it could be like this, just like this always.'

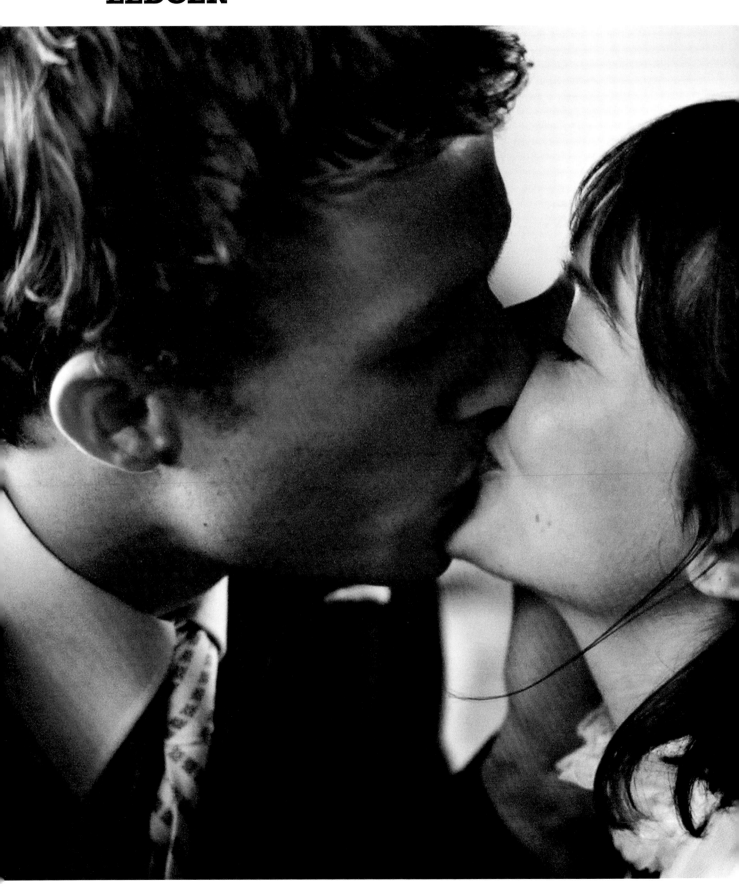

A marital kiss

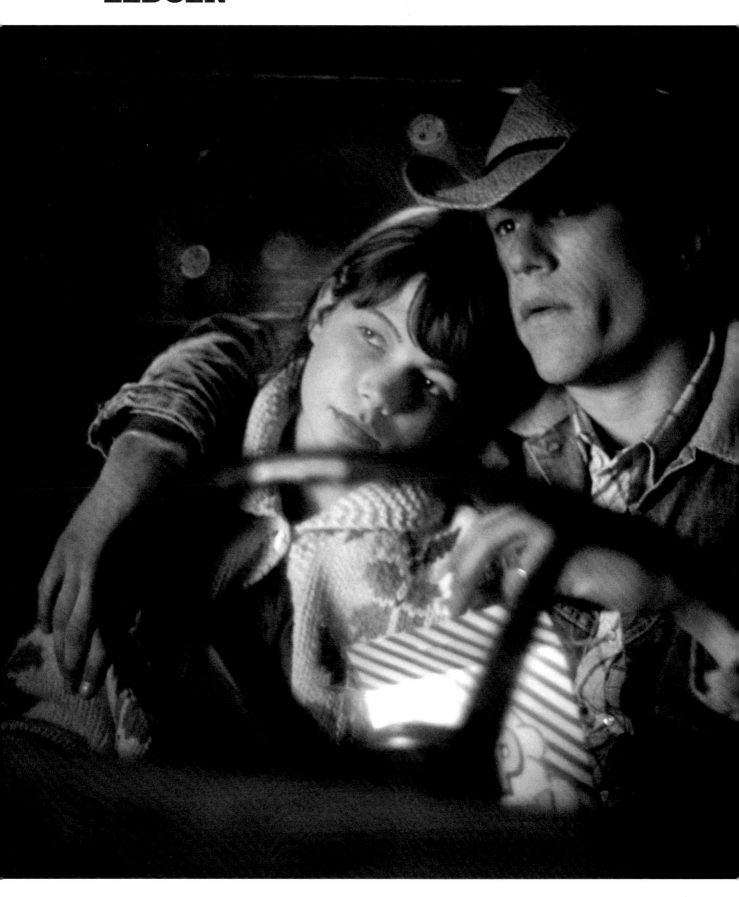

'You didn't go up there to fish!'

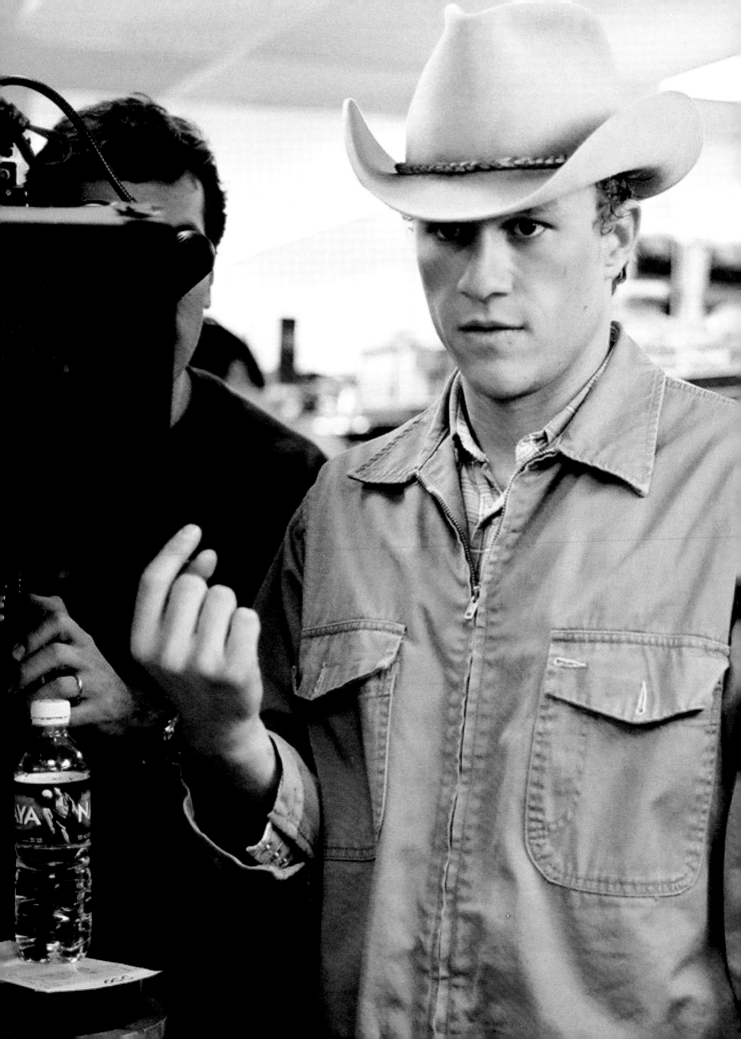

Heath Ledger with
director Ang Lee.

SEVEN:

GETTING UNDER THE SKIN

'I don't have a technique. I've never been a believer in having one set technique on how to act. There are no rules and there is no rulebook. At the end of the day, it all comes down to my instincts. That's the one thing that guides me through every decision professionally. Socially, also. That's my technique.'

Heath and Michelle had very little time together before Heath left for Venice, where he was to star as the eponymous hero in Lasse Hallstrom's *Casanova*. After the intensity of work on *Brokeback Mountain,* Heath found the extended location shoot in Venice to be an ideal opportunity to wind down. Co-starring Sienna Miller, Jeremy Irons and Omid Djalili, Hallstrom's vision of the story of the eighteenth-century libertine was a fairytale romp. '*Brokeback Mountain* was such an excruciating shoot, pretty horrendous at times. This was like a working holiday by comparison.' Since his profession had ramped up the tension, Ledger needed something comparable to help him unwind. 'I couldn't just go home; I would have gone mad. So I went to Venice, floated around the city, drank wine, ate pasta. I needed to breathe, relax... and got paid for it.' The movie added up to six months in Venice, a 'beautiful' interlude, according to Ledger. He was picked up by boat every morning. The whole experience was 'just magic and it was

fun. We didn't take it seriously whatsoever – it's Tom Stoppardish, certainly not Fellini's version of *Casanova*.' The film provided a working holiday, an elaborate extended period of unwinding, during which Ledger could unravel himself from *Brokeback Mountain.*

After the fun of *Casanova,* Heath almost immediately left for Australia to film *Candy*, a story of passion and drug addiction. The script, by Luke Davies, was based on Davies's former life as a drug addict. Heath was cast as Dan, a poet and heroin user who falls in love with a young woman called Candy (beautifully played by Abbie Cornish). They marry and both become irrevocably addicted to heroin. The film records the results of their attachment to 'candy', including Dan pushing Candy into prostitution to raise money for their habit. As the marriage deteriorates, so does Candy's mind. Dan makes a final attempt at reconciliation but realises that in order to try to save her he has to let her go.

This was theatre director Neil Armfield's first feature film. He was to value Heath's

commitment and experience: 'I often thought Heath was under-acting. I couldn't see with my naked eye what he was doing but on the big screen, he was right, perfect. He also wanted to cut a lot of the dialogue out. I insisted on filming it anyway, then I have to say he was 90 percent right there too, because I cut the dialogue in the edit.'

Heath and his co-star visited the Narcotics Users Association of Australia to learn about the techniques addicts use to find a vein to inject and had someone on set to coach them through the stages of withdrawal. Heath also stayed away from the sun to develop an addict's pallor and lost weight. In one sequence he actually injected himself: 'I did one scene they didn't end up using. It was near the end of the movie when I inject again after being clean. There was a shot that we had, a tight shot of my arm, and I slipped the needle in and pulled back until you saw the blood, and then they went off it onto my face. I actually injected. It had water, colour and sugar in it to make it look watery brown. And then we found out that was the difference between a Mature rating and an R: the penetration. When it looked like it was going in and it didn't really go in, that was OK.'

With the end of filming on *Candy,* Heath came to the end of an intensive period of film-making. There were four movies waiting in line to be released. *Lords of Dogtown* opened on 3 June 2005 to good reviews, probably best characterised by this from *Rolling Stone*: 'Stacy Peralta made a slamming 2001 documentary, *Dogtown and Z-Boys*, about the Zephyr skateboarders from Venice, California, who revolutionized the sport in the 1970s. Now Peralta, one of the original Z-Boys, goes Hollywood on himself by recasting his doc as a feature film. His script, directed with

vigour and wit by Catherine Hardwicke – best known for tracking the extreme sport of teen sex in *Thirteen* – interjects a love triangle, a drug trauma and several identity crises. But the film grabs you hard as Peralta (John Robinson), Jay Adams (Emile Hirsch) and Tony Alva (Victor Rasuk) move from surf to street, practice in drained swimming pools and get famous and fucked up for doing what they love. Hardwicke whips up a frenzy of crazy-cool board action, with Alva choreographing the stunts. Even when the slippery-slope-of-success clichés halt the film's momentum, the ready-to-rock actors rev it up again. Heath Ledger is flamboyantly funny and alive as Z-Boys guru Skip Engblom. Don't freak that Rasuk, Robinson and Hirsch have skating doubles: their performances cut deep, putting a human face on a dazzling daredevil ride.'

Next in line was the delayed *The Brothers Grimm*. The movie opened on 26 August 2005, and the reviewers were decidedly cool, commenting on the triumph of the film's style (wonderful sets and atmosphere) over its content (weak script, overacting). The one bright spot was the public announcement of Michelle Williams's pregnancy. Heath had known that he and Michelle were to become parents while he was filming *Candy*, later commented on how harrowing he had found filming the miscarriage scene: 'I don't usually get disturbed by scenes, no matter how dark they are but that was really tough.'

Following the US release of *The Brothers Grimm*, Heath left almost immediately for the Venice Film Festival where that film and *Brokeback Mountain* were entered for the festival's premiere Golden Lion award and *Casanova* was to be screened for the first time. One paper suggested that it should be

re-named the 'Heath Ledger Film Festival' – which turned out to be remarkably prescient, as *Brokeback Mountain* triumphantly carried off the Golden Lion.

The movie was commercially released at the end of November, to critical acclaim and audience enthusiasm. *Brokeback Mountain* took over $80million in the US alone. *The New York Times'* said: 'Both Mr Ledger and Mr Gyllenhaal make this anguished love story physically palpable. Mr Ledger magically disappears beneath the skin of his lean, sinewy character, as good as the best of Marlon Brando and Sean Penn. The pain and disappointment felt by Jack, who is softer, more self-aware and self-accepting, continually registers in Mr Gyllenhaal's sad, expectant silver-dollar eyes.' The *Los Angeles Times* put Heath's performance in context: 'Aside from his small but strong part in *Monster's Ball*, nothing in the Australian-born Ledger's previous credits prepares us for the power and authenticity of his work here as a laconic, interior man of the West, a performance so persuasive that *Brokeback Mountain* could not have succeeded without it. Ennis's pain, his rage, his sense of longing and loss are real for the actor and that makes them unforgettable for everyone else.'

Brokeback Mountain was nominated for eight Oscars, including Best Picture, Best Director and Heath for Best Actor. In spite of the enormous enthusiasm for the film, on Oscar night it won only three awards, Best Score for Gustavo Santaolalla, Best Screenplay Adaptation for Diana Ossana and Larry McMurtry, and Best Director for Ang Lee. The film won many more awards worldwide. For Ledger, this was the movie where he had realised all his acting skills and synthesised them into a performance of true greatness.

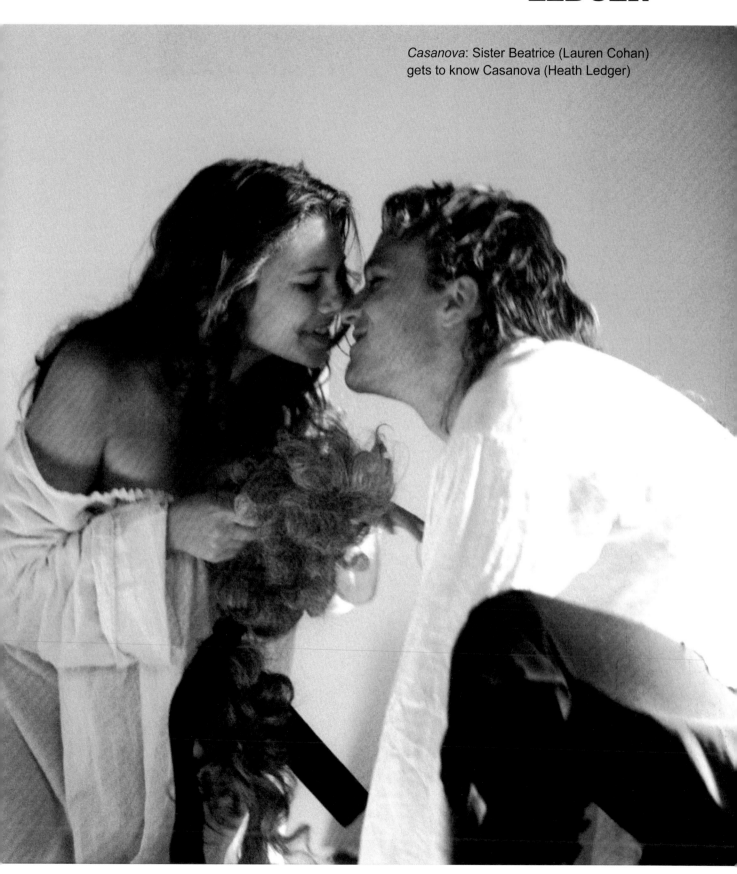

Casanova: Sister Beatrice (Lauren Cohan) gets to know Casanova (Heath Ledger)

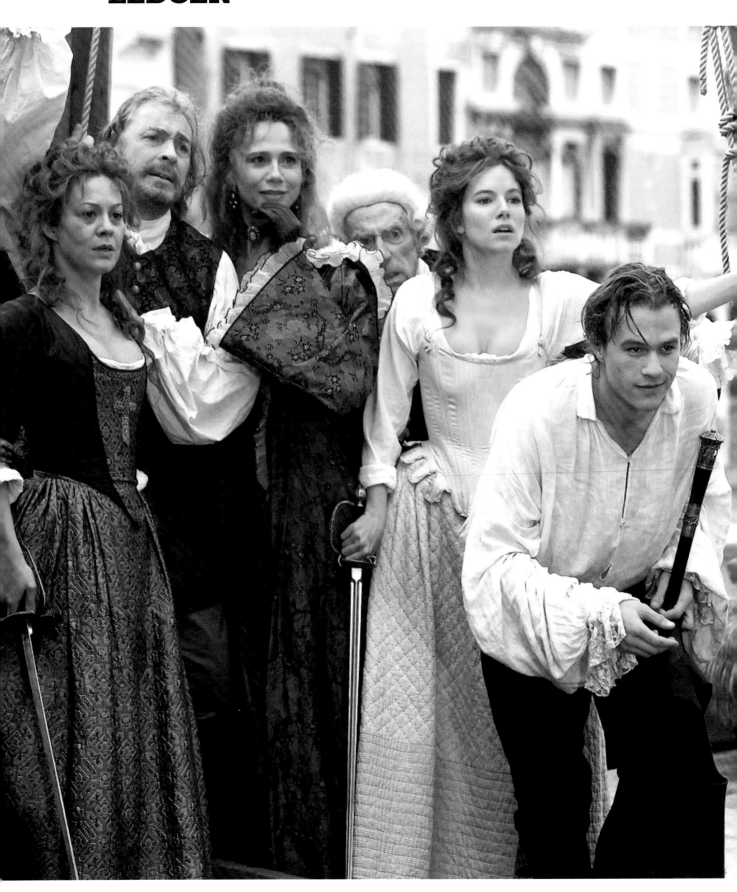

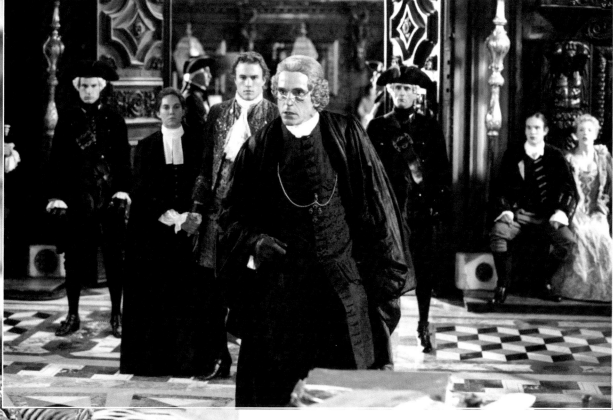

ABOVE: Big trouble: Pucci (Jeremy Irons)
complains to the Doge about Casanova's behaviour.

LEFT: Andra (Lena Oliver), Tito (Leigh Lawson),
Casanova's mother (Helen McCrory), Vittorio
(Paddy Ward), Francesca (Sienna Miller) and Casanova

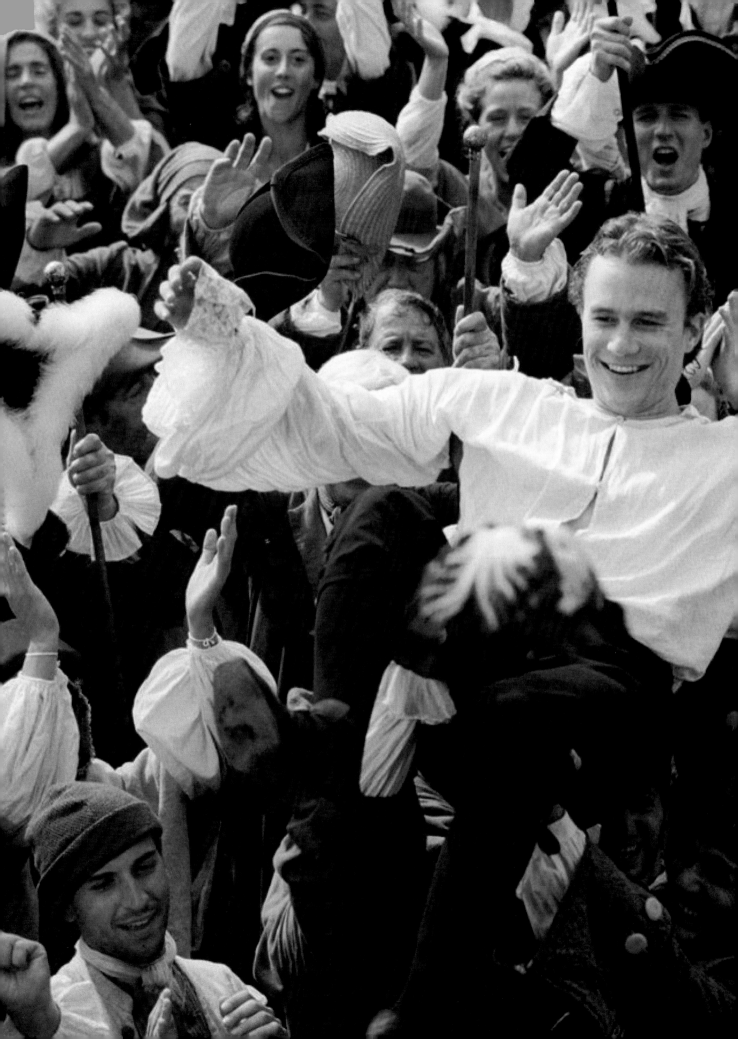

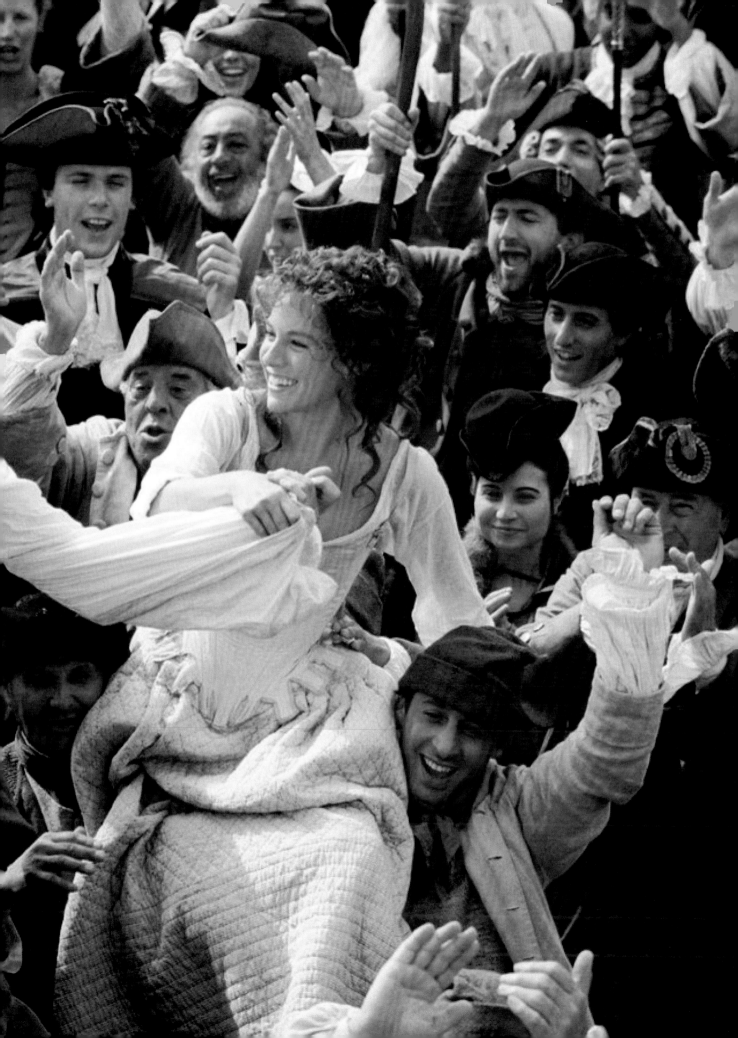

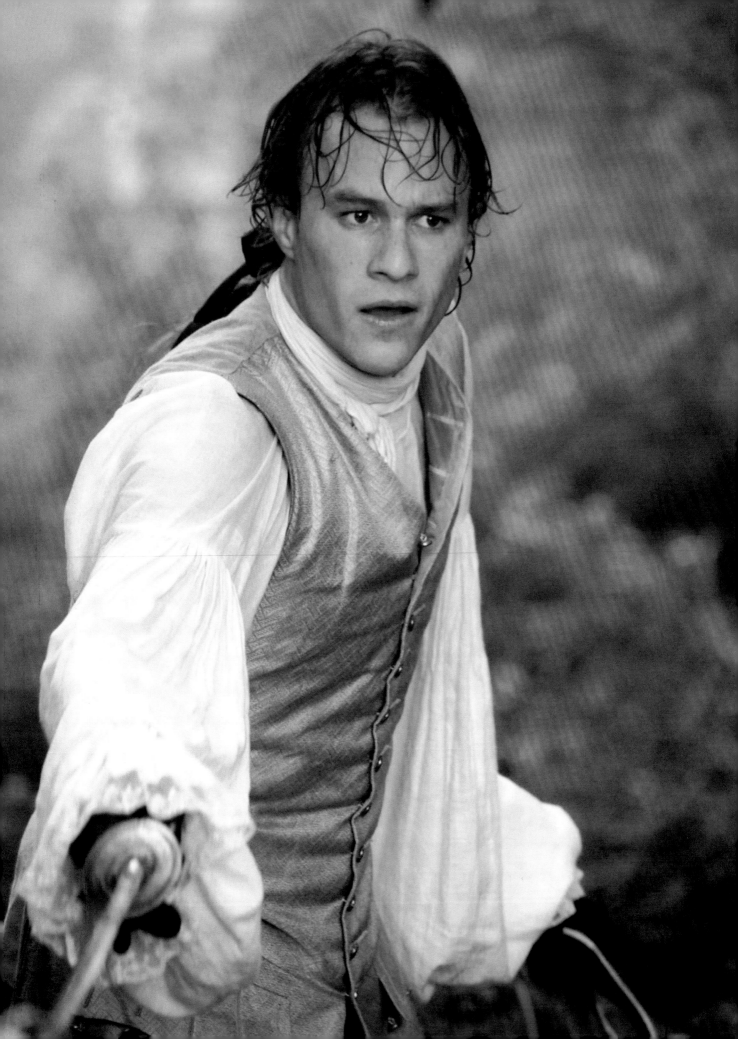

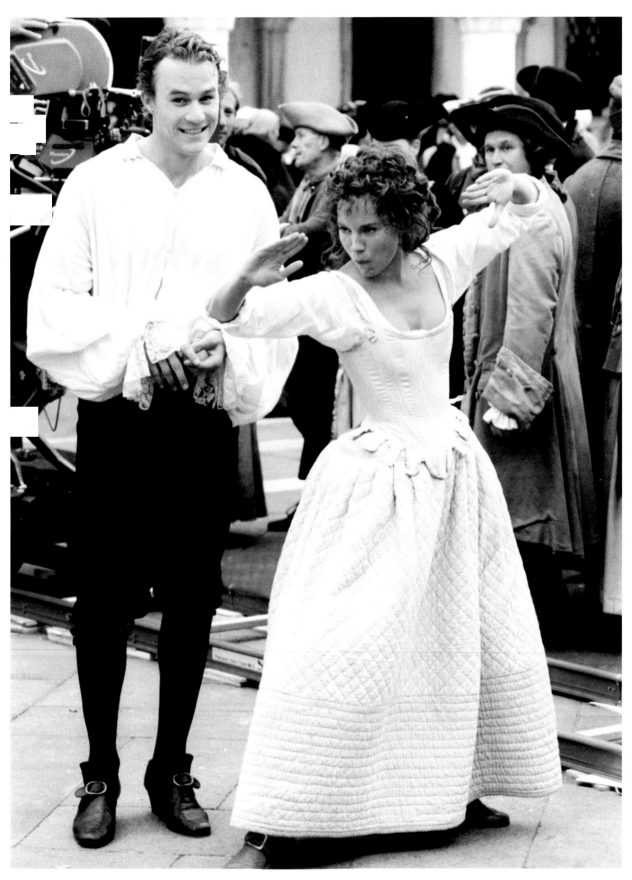

LEFT: En garde!
ABOVE: Sienna Miller tries a move.

LEFT AND ABOVE: *Candy*: Candy (Abbie Cornish)
and Dan (Heath Ledger)

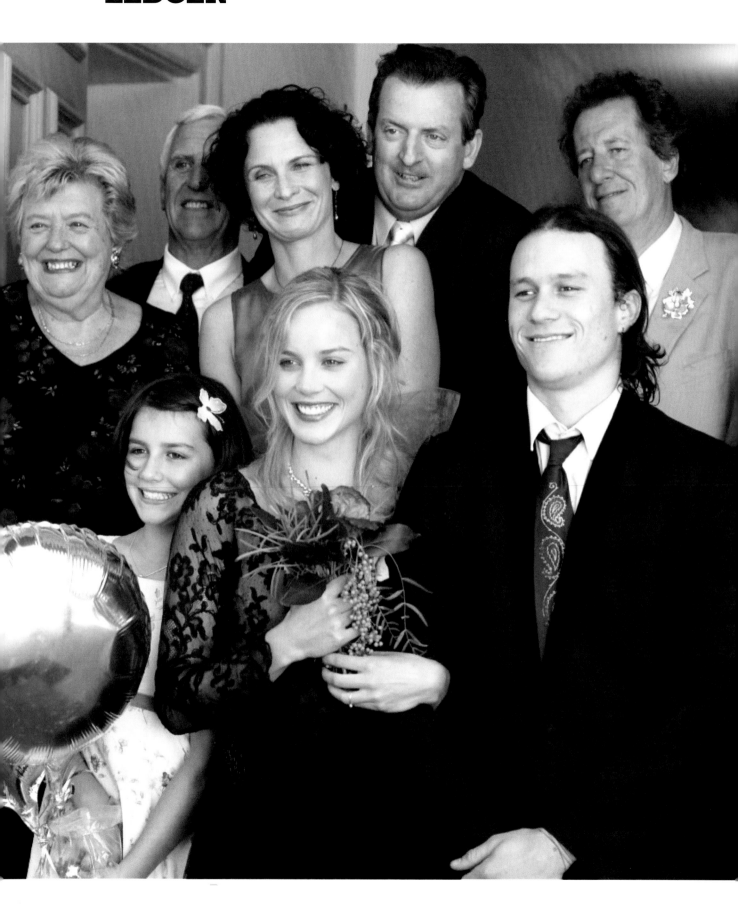

'I wasn't trying to wreck Candy's life.
I was trying to make mine better.'

HEATH
LEDGER

'That was beautiful.
Let's have some more.'

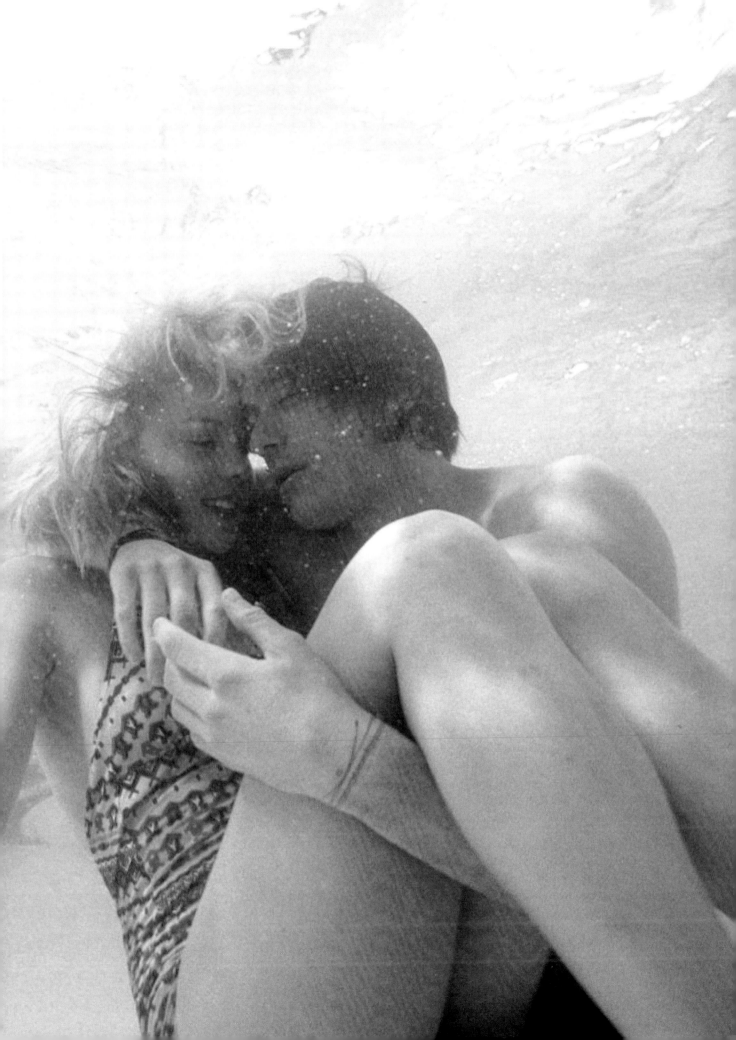

HEATH LEDGER

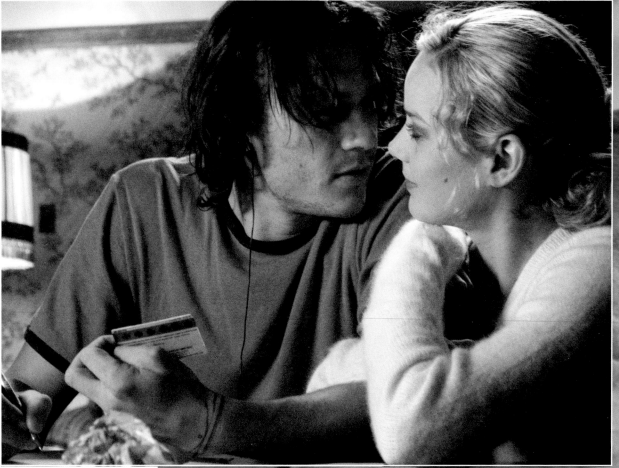

ABOVE: 'I wanna try
it your way this time'

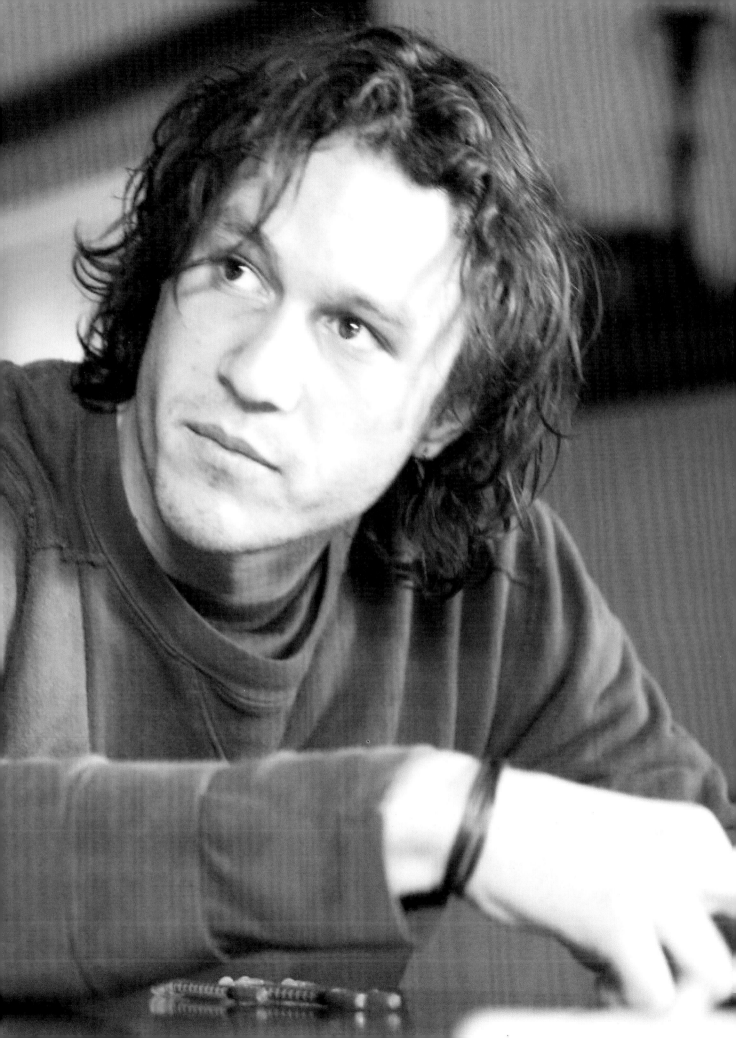

'More is never enough.'

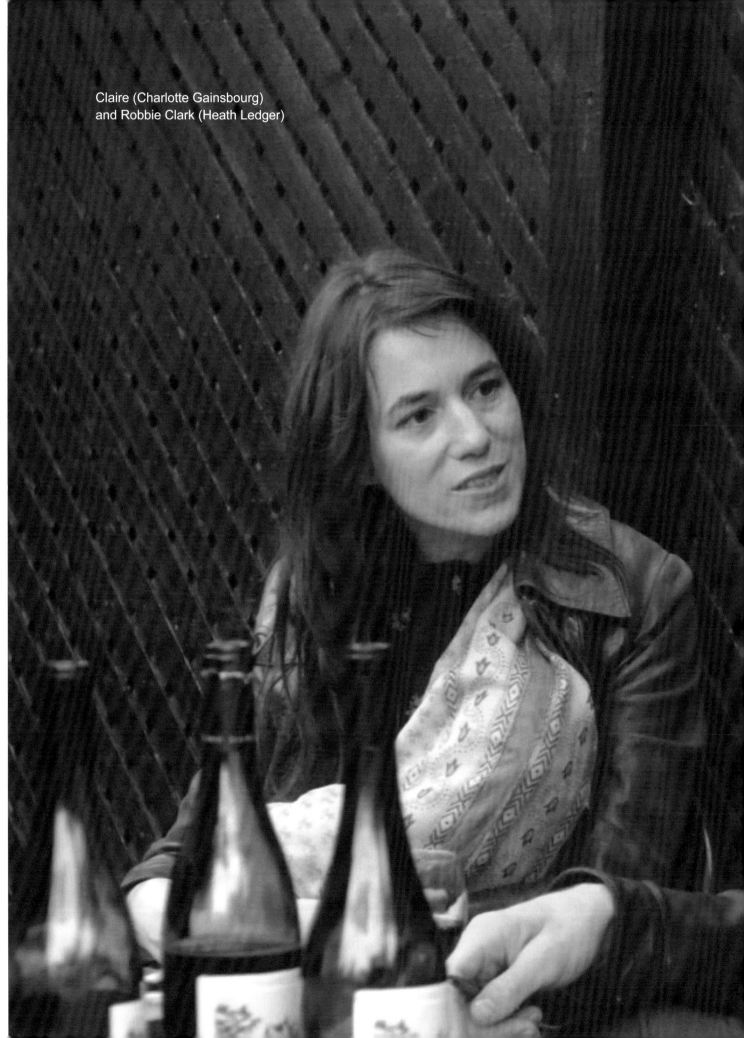

Claire (Charlotte Gainsbourg)
and Robbie Clark (Heath Ledger)

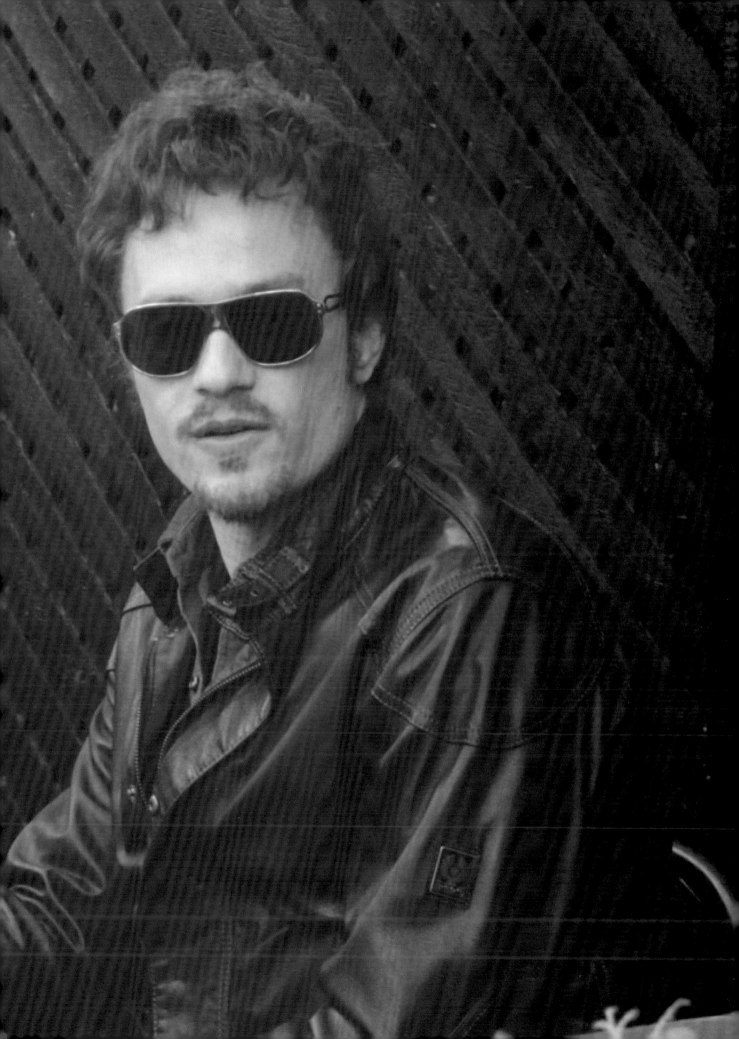

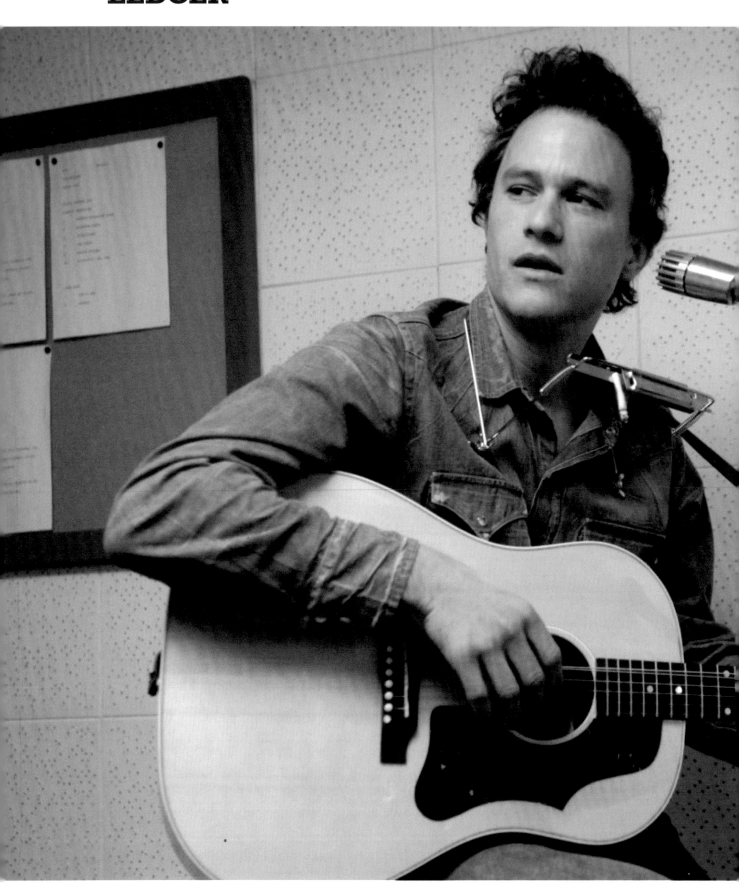

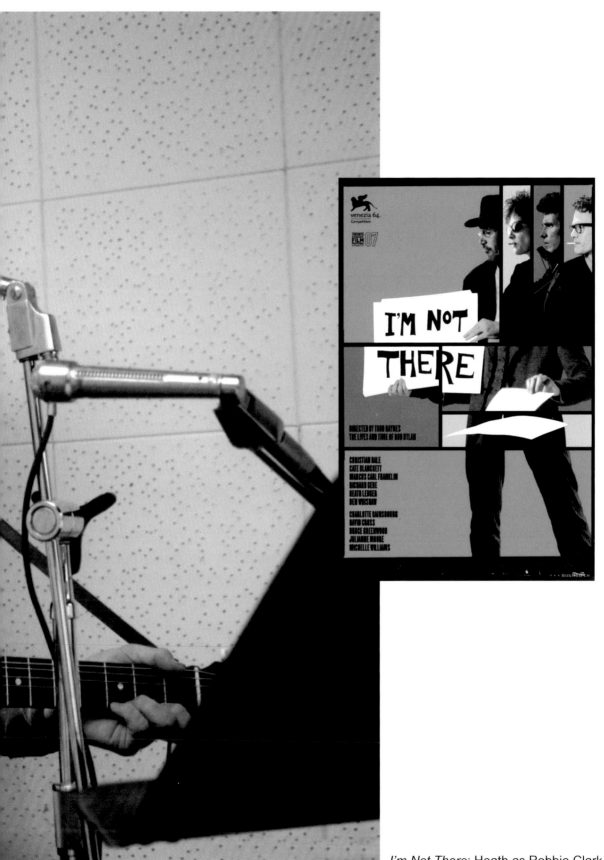

I'm Not There: Heath as Robbie Clark

NINE:

SEE THE WORLD BURN

'[The Joker is a] psychopathic, mass murdering, schizophrenic clown with zero empathy. ...Last week I probably slept an average of two hours a night. I couldn't stop thinking. My body was exhausted, and my mind was still going.'

The Venice Film Festival enabled Heath to take a short break from the filming of *The Dark Knight*, Christopher Nolan's second Batman movie with Christian Bale as Batman. Heath was cast as the Joker, a role he created with his, now, normal thoroughness and intensity. Deliberately separating himself from Jack Nicholson's interpretation of the role in Tim Burton's film, Ledger said: '...it's obviously not going to be what Jack Nicholson did. It's going to be more nuanced and dark and more along the lines of *A Clockwork Orange* kind of feel. Which is, I think, what the comic book was after: less about his laugh, more about his eyes.' In another interview he remarked: 'The Joker is pure anarchist. I definitely have a different take on him. He's going to be really sinister, and it's going to be less about his laugh and his pranks. I'm not really thinking about the commercial consequences – maybe I should be. I can just tell you I love to dress up and wear a mask.'

The Joker's 'look' is a compelling part of his personality. The costume designer wanted the way he looked to reflect his persona – 'he doesn't care about himself at all'. Nolan commented: 'We gave a Frances Bacon spin to [his face]. This corruption, this decay in the texture of the look itself. It's grubby. You can almost imagine what he smells like.' Heath described his 'clown mask' as 'new technology', the three pieces of stamped silicone taking only an hour for the make-up artists to apply and feeling as if he was wearing hardly any make-up at all.

To help himself to get into the role Heath lived in a hotel in London for a month, formulating the character's voice and personality, creating a 'Joker diary' filled with images and thoughts helpful to the Joker back story, like a list of what the joker would find funny (Aids was one of them): 'I ended up landing more in the realm of a psychopath – someone with very little to no conscience towards his acts... just an absolute sociopath, a cold-blooded mass-murdering clown... There are no real boundaries to what the Joker

would say or do. Nothing intimidates him and everything is a big joke.'

So committed was he to the role that, Aaron Eckhart (who played Harvey Dent/Two-Face) recalled that Heath frequently stayed in character long after a take was over. Michael Caine (who plays the butler Alfred in the movie) commented: 'Jack was like a really scary, nasty old uncle with a funny face. Heath is like the most murderous psychopath you've ever seen on the screen, he's fantastic.'

Director Christopher Nolan decided that there would be no Joker back story in the film: 'We never wanted to do an origin story for the Joker in this film... the arc of the story is much more Harvey Dent's; the Joker is presented as an absolute. It's a very thrilling element in the film, and a very important element, but we wanted to deal with the rise of the Joker, not the origin of the Joker.'

Far from just being a 'shoot-'em-up' action thriller, over-relying on stunts and CGI effects, where the good end well and the evil badly, there is, at the heart of the film, an exploration of the shades of grey in moral decisions. The Joker has no motive apart from a desire to wreak havoc and 'see the world burn'. This amoral character creates a series of situations which present the forces of law and order with impossible ethical choices, the film concluding with the flight of Batman after he takes the blame for Dent's murders.

The production had a heavy shooting schedule, starting in April 2007 on location in Chicago, followed by extended filming at Pinewood Studios near London. Final location photography was completed in Hong Kong, by the middle of November in the same year.

In spite of the heavy demands placed on him by the role of the Joker, Heath was soon at work on a new project. Filming of Terry Gilliam's new movie *The Imaginarium of Doctor Parnassus* began in London in December 2007. The typically imaginative Gilliam story line told the tale of 1000-year-old Dr Parnassus (Christopher Plummer) leading a theatre troop in modern London. By doing a deal with the Devil (Mr Nick, played by Tom Waits), Parnassus had been able to take audience members through a magical mirror to explore their imaginations. The time has come for the Devil to collect on the deal by demanding the doctor's daughter (Lily Cole). Heath was cast as Tony, a mysterious character who joins the troupe and who attempts to save the girl from the Devil's clutches.

Gilliam wrote the script with Charles McKeown, who had worked on Gilliam's earlier film *The Adventures of Baron Munchausen.* The director described the project as a 'fun and humorous story about the consequences of our personal experiences in life. ...It's autobiographical. I'm trying to bring a bit of fantasticality to London, an antidote to modern lives. I loved the idea of an ancient travelling show offering the kind of storytelling and wonder we used to get, to people who are just into shoot-'em-up action films.' The character of Tony was based on British prime minister Tony Blair who, 'would say the most insane things and probably he'd believe them himself.'

According to Gilliam, Heath improvised 'half' his comedy dialogue. 'I really felt "We got a tiger by the tail here! I thought here's somebody with the kind of energy I had when I was young. Location photography in London was completed by mid-January 2008. Completion of the film was to take place in Vancouver. Co-star Christopher Plummer said later about the location shoot: 'We all caught

HEATH LEDGER

colds because we were shooting outside on horrible, damp nights; what's more he [Heath] was saying all the time, "Dammit, I can't sleep!" and he was taking all these pills.'

On 19 January Heath left London for New York to have a break before resuming filming in Canada. On 22 January he was found apparently unconscious in his SoHo apartment. Paramedics failed to revive him and he was pronounced dead at the scene. Test showed that he had died as a result of taking a mixture of legally prescribed drugs to counter sleeplessness and anxiety. None of the drugs were at a lethal level on their own. All the evidence pointed to the fact that the 28-year-old actor had accidentally ingested a cocktail of medicines that proved fatal.

Heath's body was flown back to his hometown of Perth, Australia where he was cremated at a simple ceremony attended by a group of ten close family members.

Heath plays The Joker in *The Dark Knight*. 'Oh, criminals in this town used to believe in things. Honor. Respect. Look at you! What do you believe in, huh?'

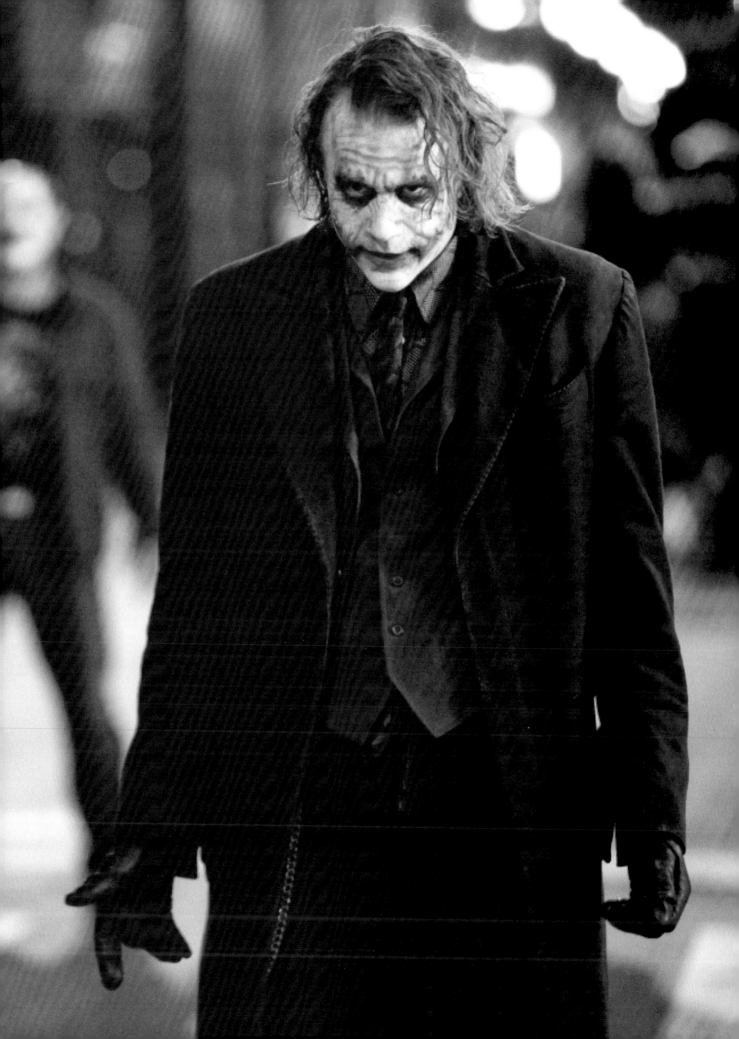

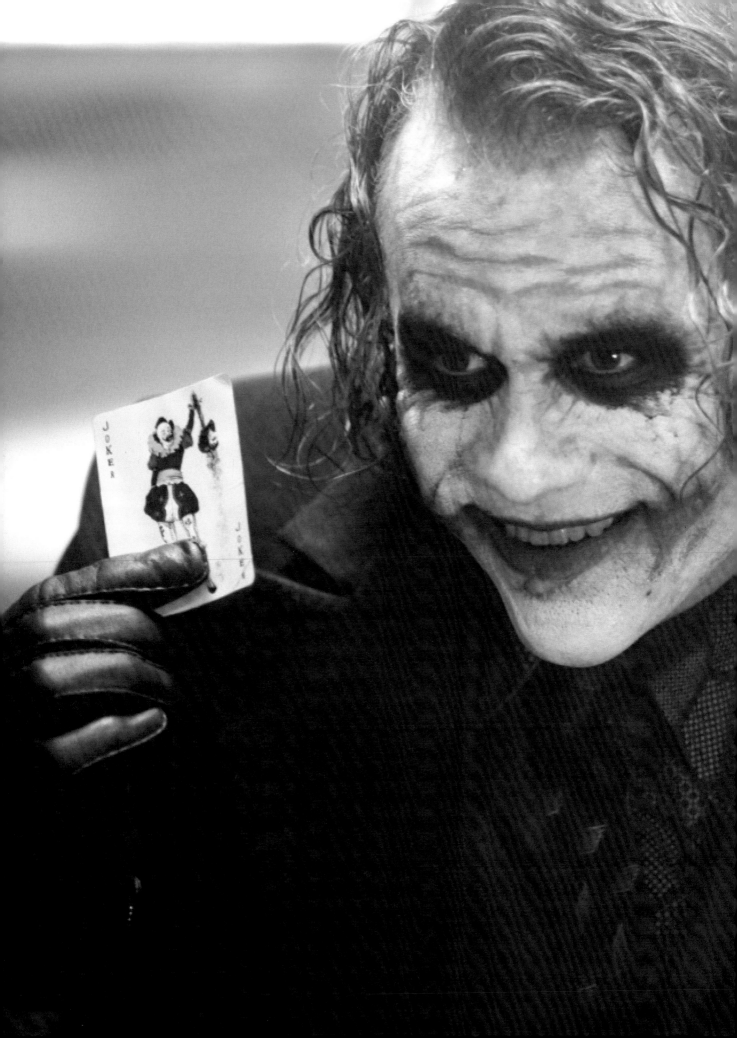

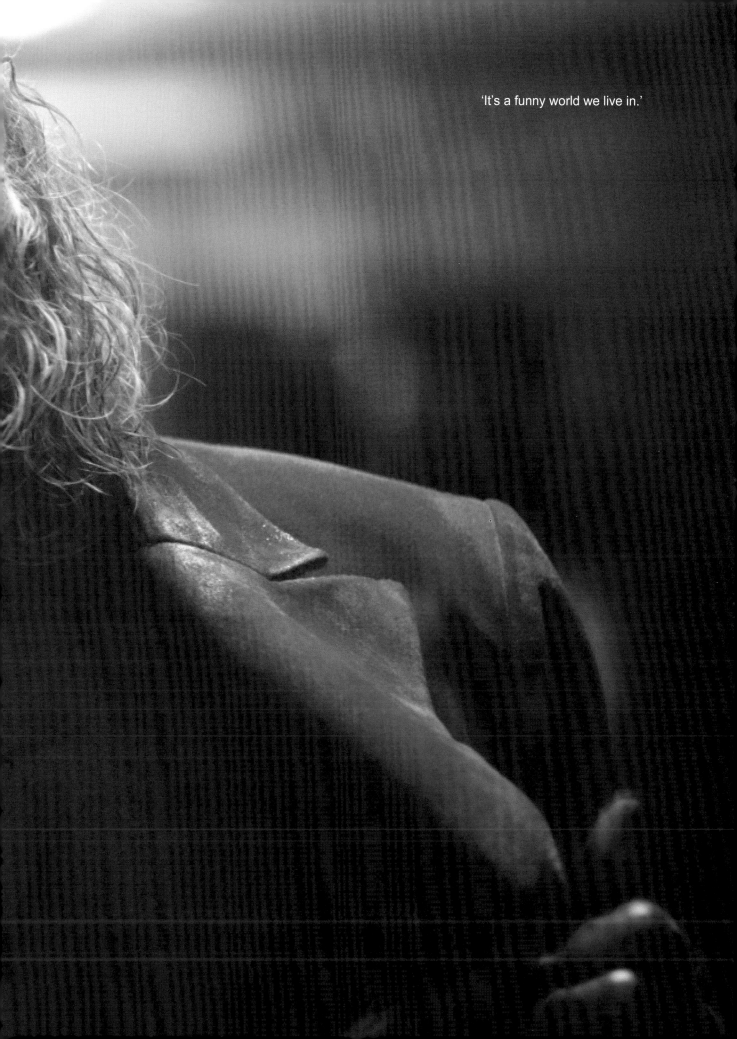

'It's a funny world we live in.'

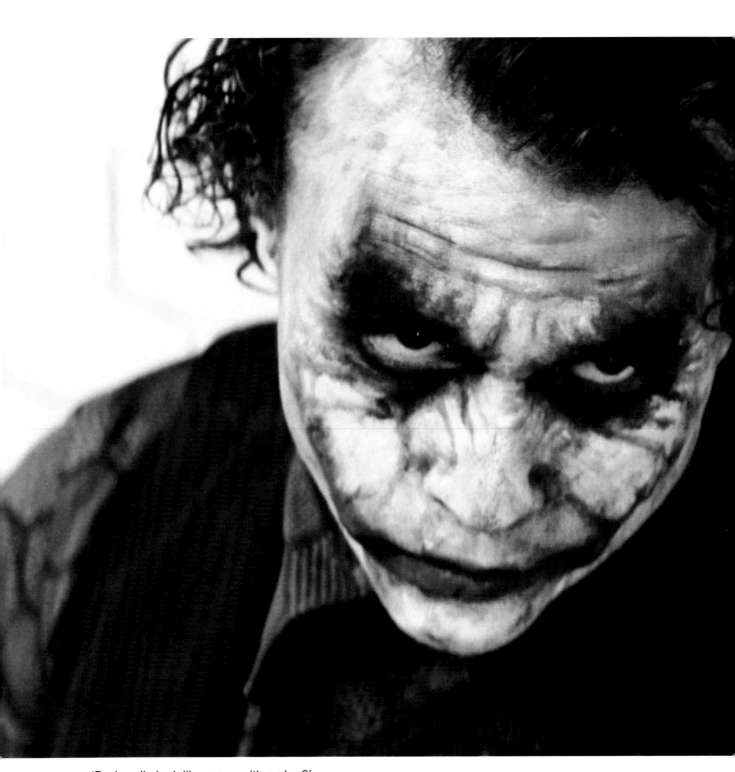

'Do I really look like a guy with a plan?'

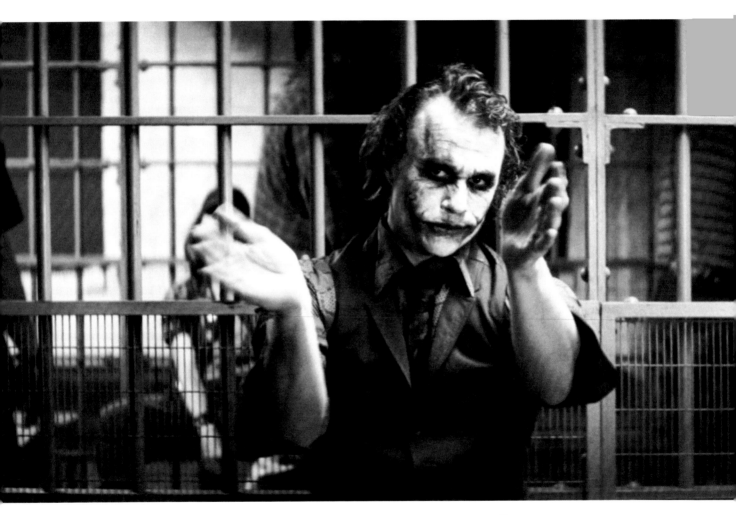

'Well, you look nervous. Is it the scars? You want to know how I got 'em?'

RIGHT: Christian Bale as Batman in *The Dark Knight.*

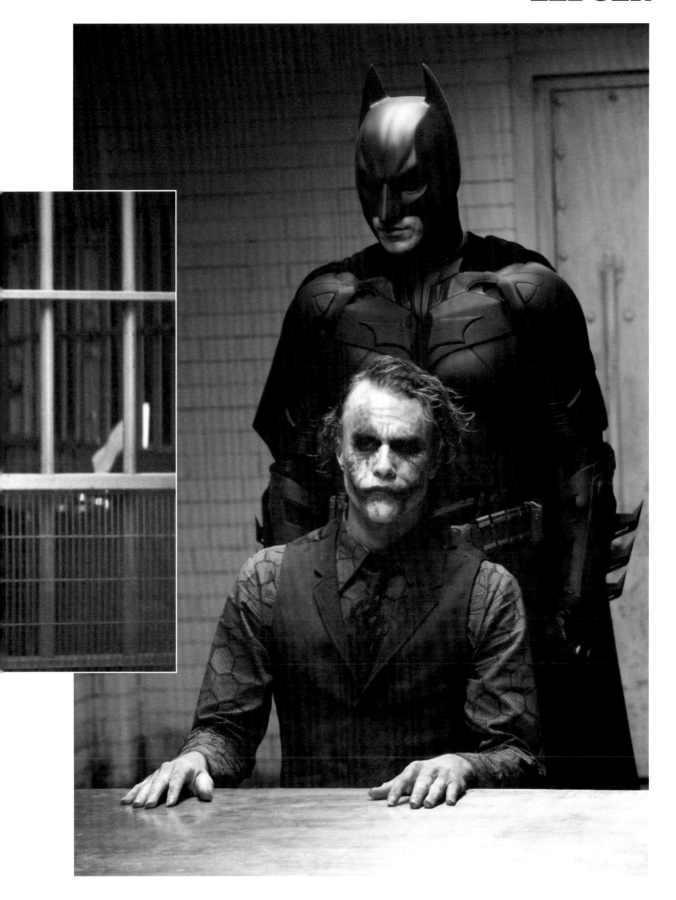

115

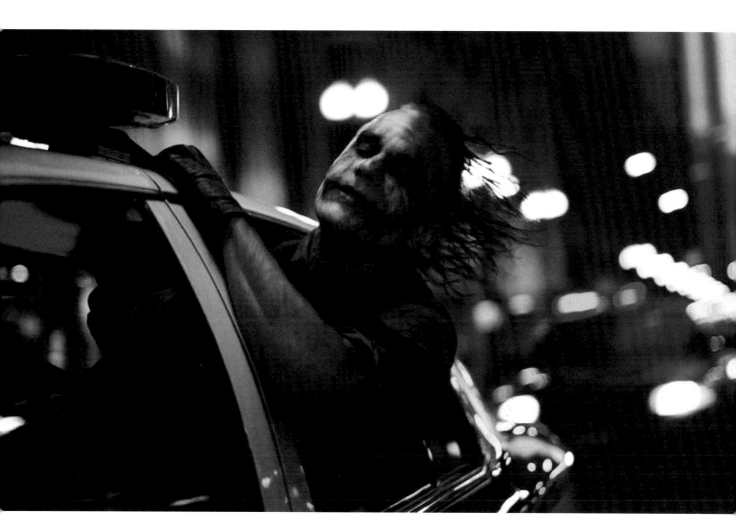

'Let's put a smile on that face!'

'I'm not a monster. I'm just ahead of the curve.'

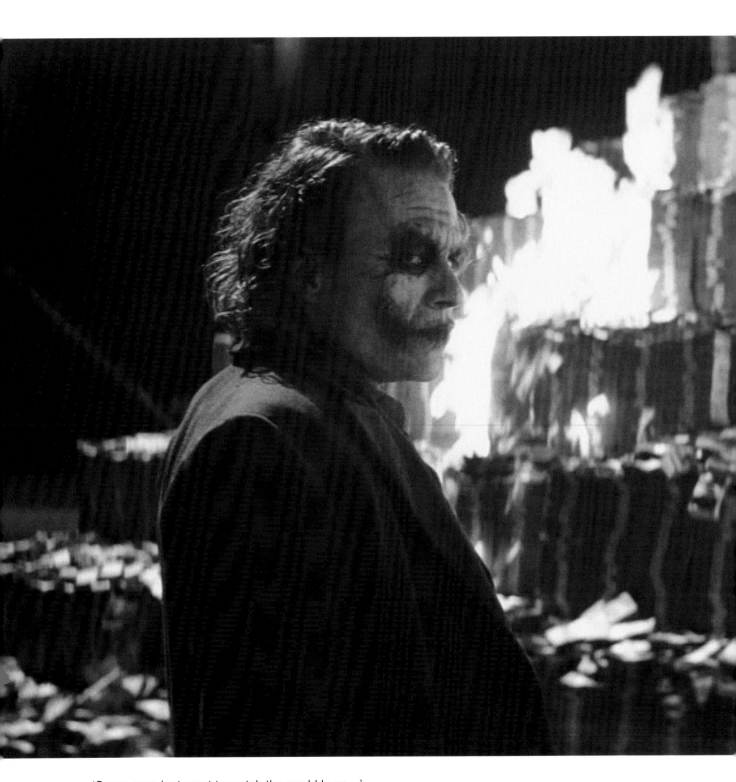

'Some men just want to watch the world burn…'

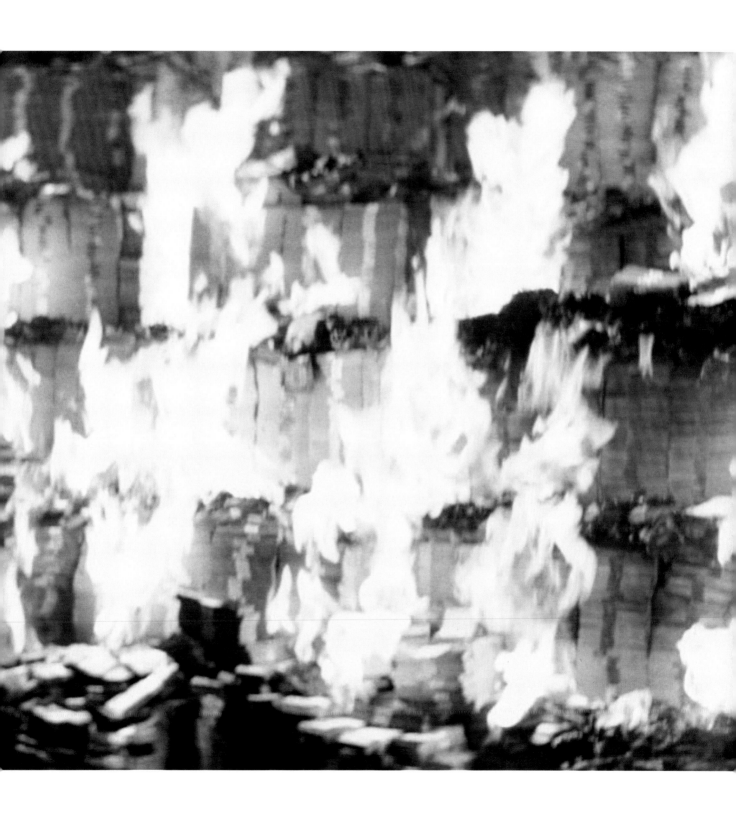

HEATH
LEDGER

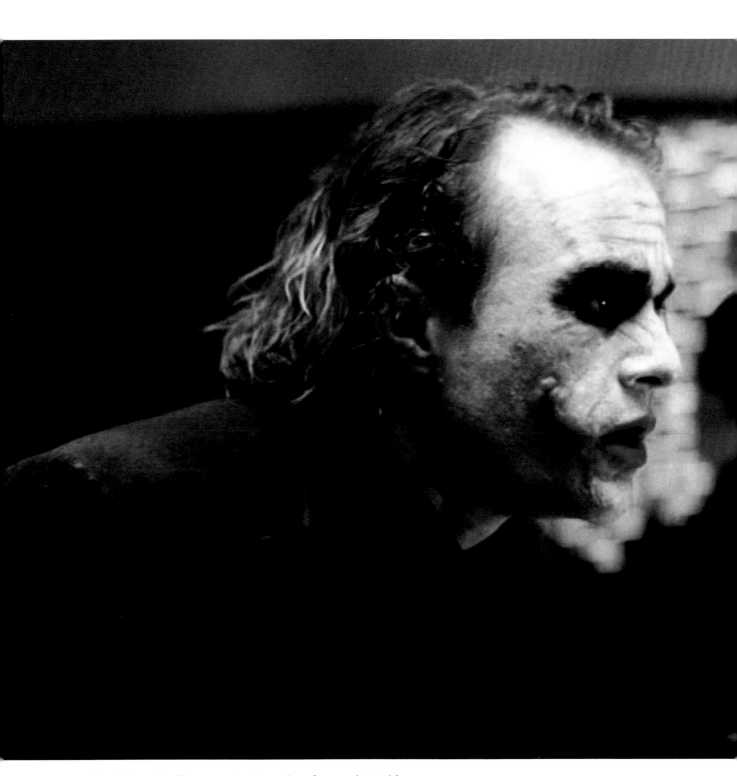

'I ended up landing more in the realm of a psychopath'

TEN:

CURIOSITY... AND A THIRST

'Working with Heath was one of the purest joys of my life. He brought to the role of Ennis more than any of us could have imagined – a thirst for life, for love, and for truth, and a vulnerability that made everyone who knew him love him. His death is heartbreaking.' Ang Lee

Heath's death occurred while director Christopher Nolan was editing *The Dark Knight*: 'It was tremendously emotional right when he passed, having to go back in and look at him every day. But the truth is, I feel very lucky to have something productive to do, to have a performance that he was very, very proud of, and that he had entrusted me to finish.' Nolan was able to complete the film using all of Heath's scenes without having to resort to digital effects.

The Dark Knight received its world premiere on 14 July 2008 in New York City. The reception from the critics was enthusiastic but reflected the moral ambivalence of the film. The final paragraph of *The New York Times* review seems to sum it up: 'In its grim intensity *The Dark Knight* can feel closer to David Fincher's *Zodiac* than Tim Burton's playfully gothic *Batman*, which means it's also closer to Bob Kane's original comic and Frank Miller's 1986 reinterpretation. That makes it heavy, at times almost pop-Wagnerian, but Mr Ledger's performance and the film's visual beauty are

transporting.... No matter how cynical you feel about Hollywood, it is hard not to fall for a film that makes room for a shot of the Joker leaning out of the window of a stolen police car and laughing into the wind, the city's coloured lights gleaming behind him like jewels. He's just a clown in black velvet, but he's also some kind of masterpiece.'

As well as its critical success the film went on to be only the second film to earn $500 million at the North American box office and the fourth highest grossing film worldwide, earning more than $1 billion. *The Dark Knight* was nominated for (and won) many awards worldwide. In 2009 Heath was awarded posthumously both a Golden Globe and an Oscar for Best Supporting Actor.

The film Heath was working on at the time of his death – *The Imaginarium of Doctor Parnassus* – had stalled, as shooting was only a third completed. Director Terry Gilliam decided to finish the film by converting Heath's role of Tony (already a slippery character) into a transformational character. Johnny Depp,

Colin Farrell and Jude Law were cast as different versions of Tony, travelling through a magical realm. Shooting restarted in Vancouver in March 2008, and the film was completed in August 2008. All three actors donated their fees to Heath's daughter Matilda.

The Imaginarium of Doctor Parnassus was shown out of competition at the Cannes Festival in May 2009 and was premiered in London on 16 October in the same year. There was a limited US release on 25 December 2009. As with many of Gilliam's films, reviews were mixed. Many acknowledged his individual vision and ability to create amazing images, while criticizing a lack of coherence and tightness in the plot. Writing in the *New Yorker* Anthony Lane said of Heath: 'It should not be mistaken for his finest hour; we see his larking but not the undertones of frailty that tugged at *Brokeback Mountain*, and his principal duty here, like everyone else's, is to go with the flow of the phantasmagoria.'

Heath's career path wasn't the acting out of his life but acting. Starting with relatively undemanding but well-crafted roles he began to discover his range and played a series of parts, each of which demanded that he find new dimensions in his acting skills. As A O Scott wrote in *The New York Times*: 'It seems to me that Mr Ledger, in his choice of roles, was motivated above all by curiosity, and perhaps also by an impatience with the predictability and caution that can settle around the shoulders of a young star.'

It is always tempting to find parallels when a career is cut short – James Dean (dead at 24), or Montgomery Clift (dead at 45), for example. And the media, as facile as ever, were happy to jump on that bandwagon. But Heath Ledger's individual body of work speaks clearly for him, and for us. His best films reflected many of the themes and anxieties of the late 1990s and the first decade of the twenty-first century – teenage romance, conflicted sexual feelings, relationships between fathers and sons, the nature of celebrity and, in *The Dark Knight*, the addictiveness of violence. It would be good to celebrate Heath Ledger's outstanding achievements, as well as speculate on what might have been.

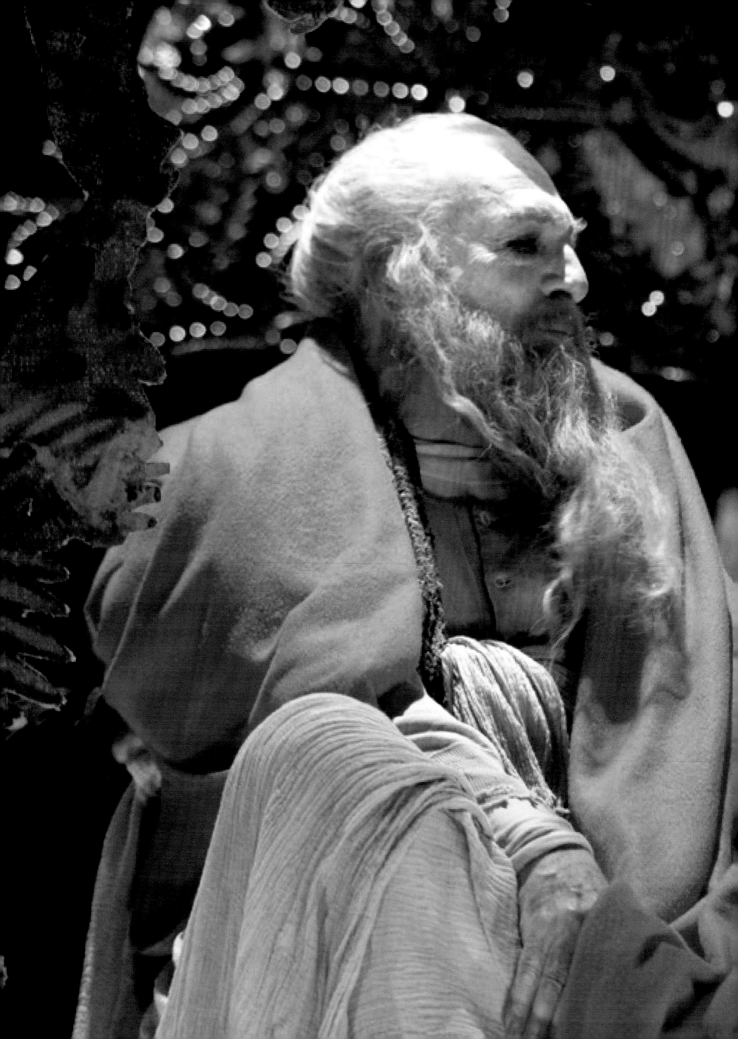

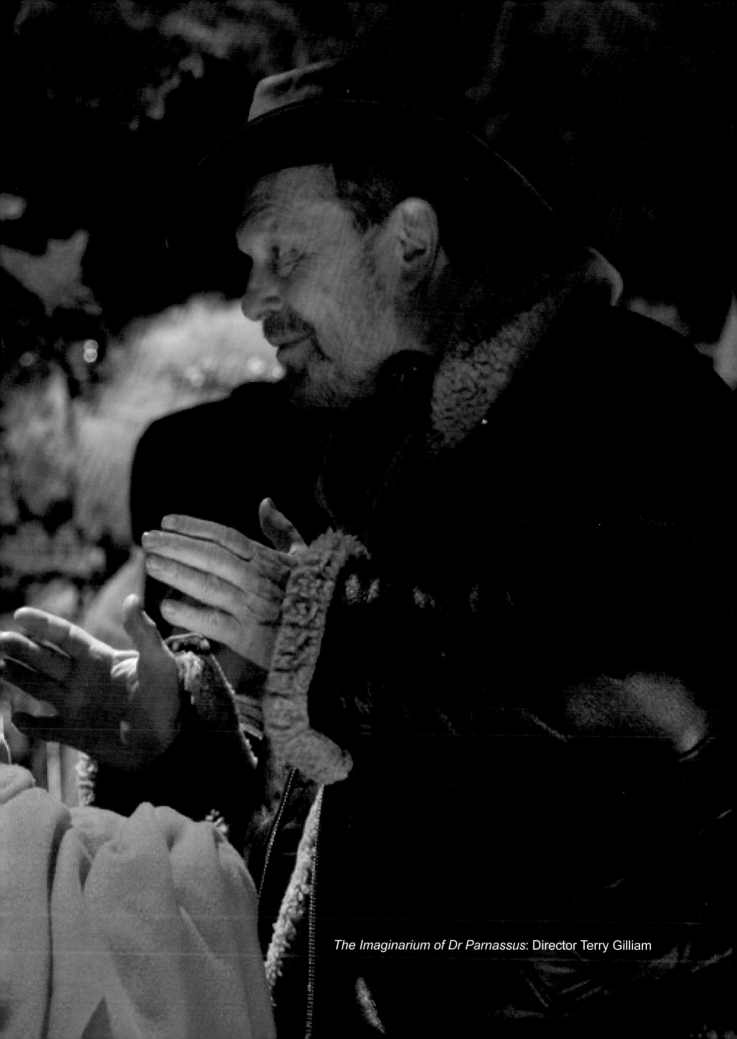

The Imaginarium of Dr Parnassus: Director Terry Gilliam

HEATH
LEDGER

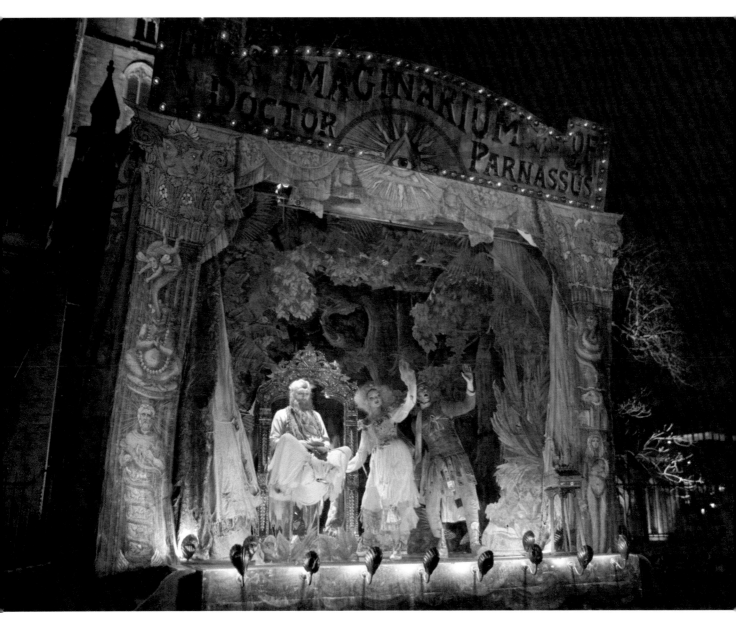

ABOVE: Let the show begin! Dr Parnassus (Christopher Plummer), Valentina (Lily Cole), Anton (Andrew Garfield).

RIGHT: Tony (Heath Ledger) and Sally (Paloma Faith)

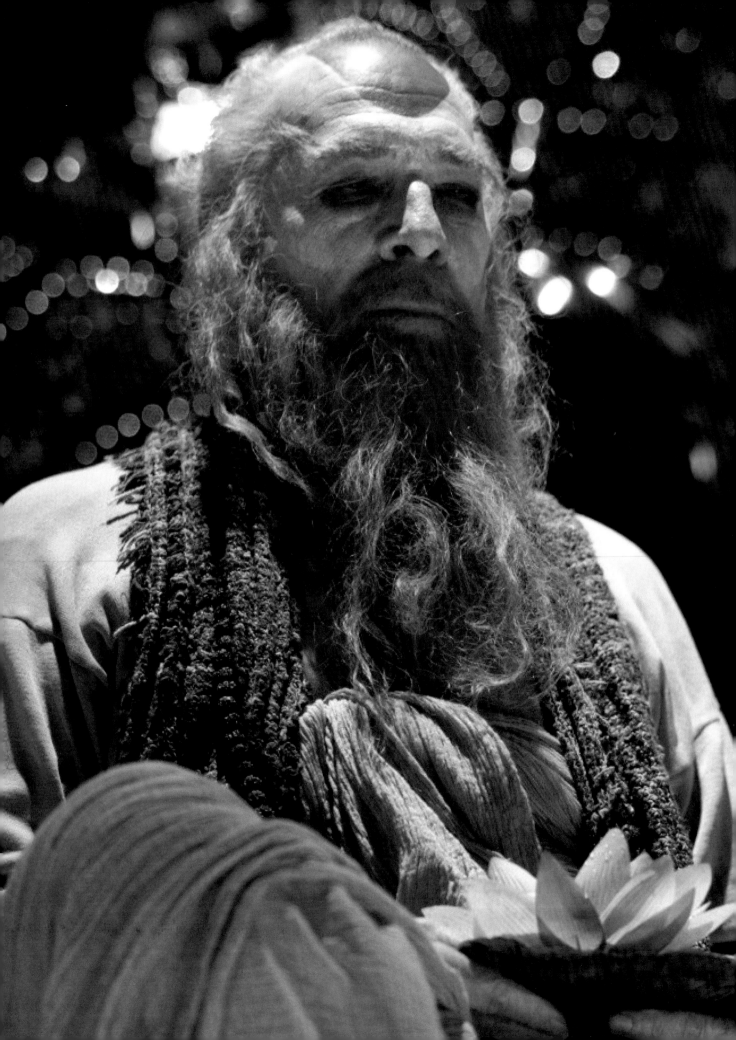

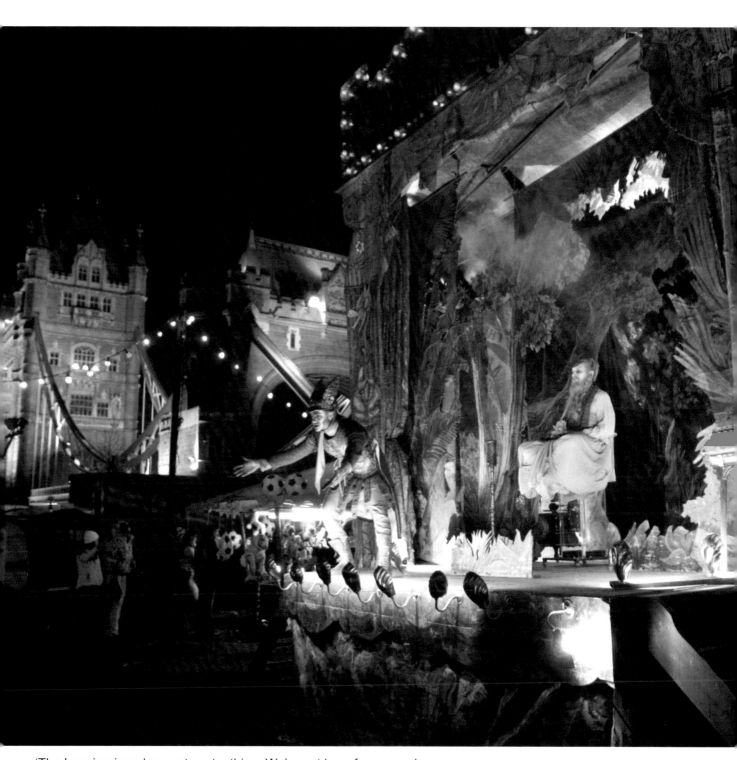

'The Imaginarium does not cost a thing. We're not here for money.'

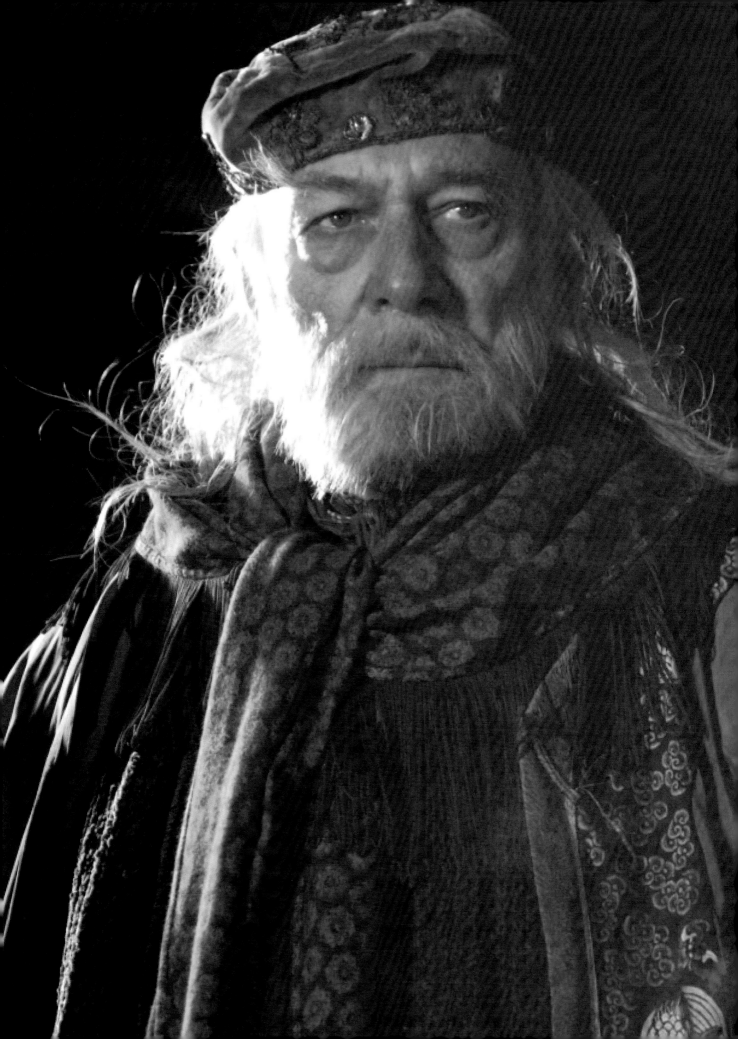

Dr Parnassus himself

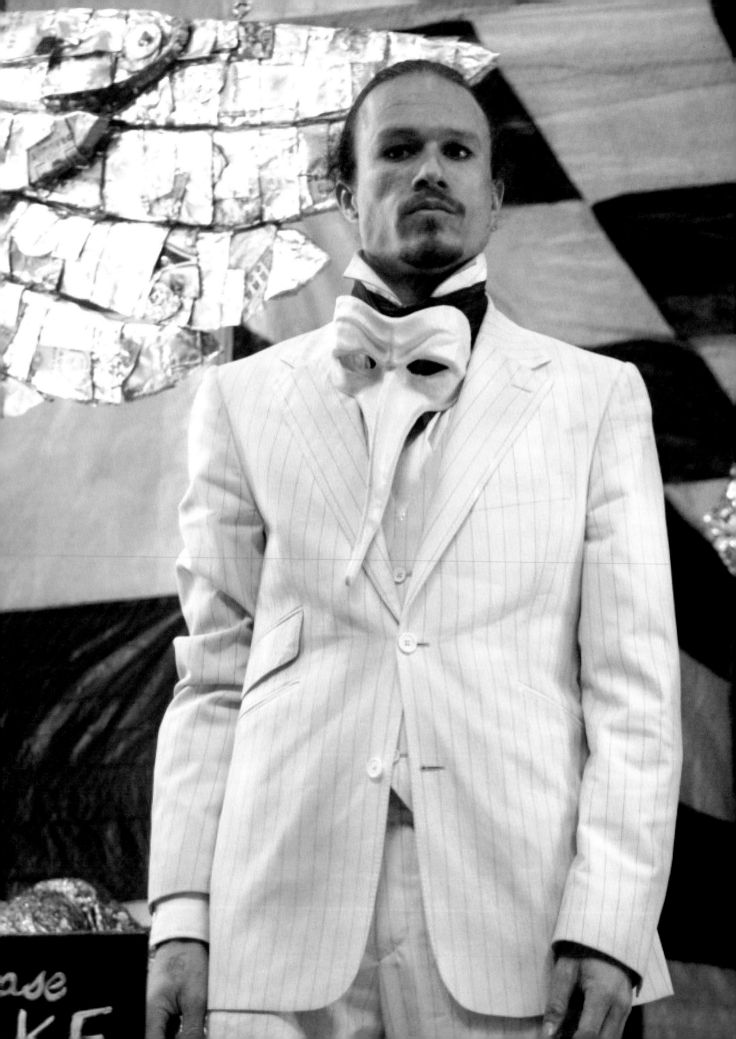

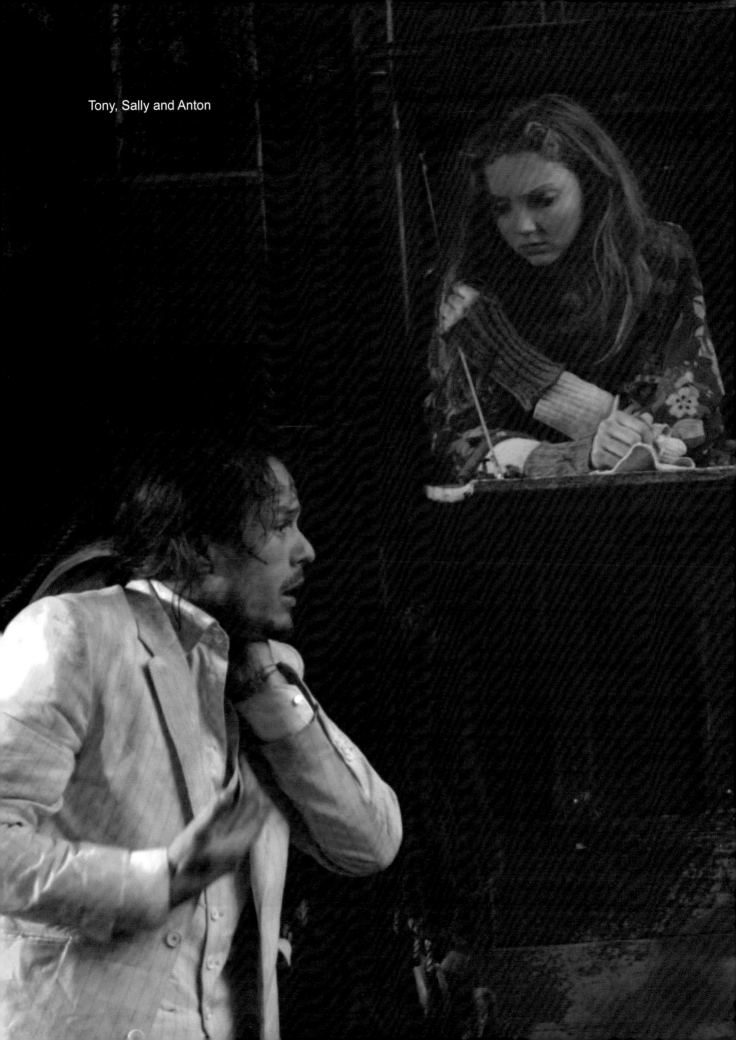

Tony, Sally and Anton

'Don't shoot the
messenger!'

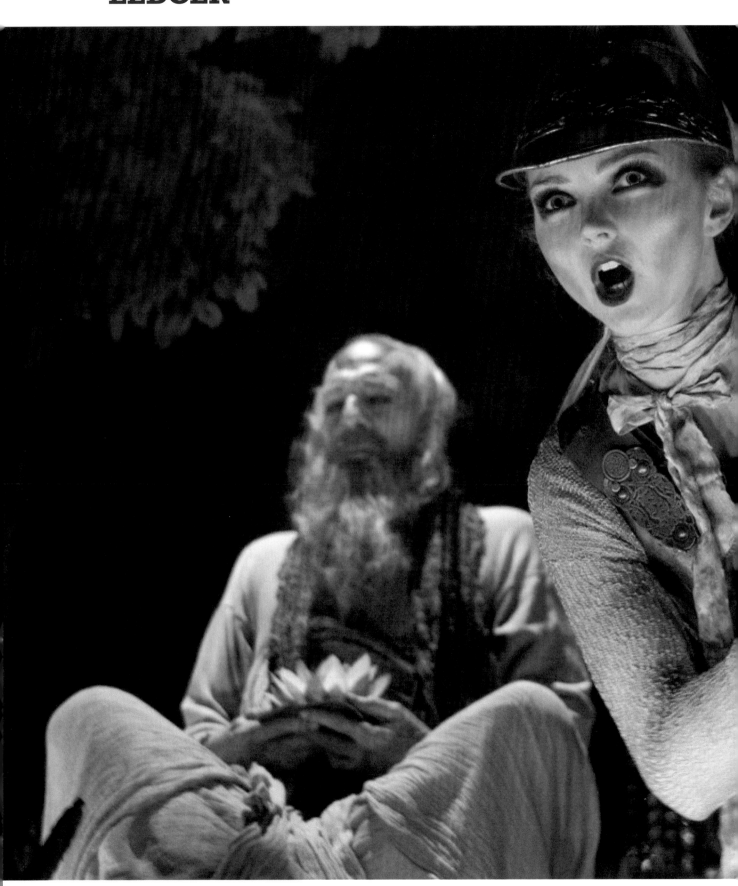

'If Doctor Parnassus
can really control
people's mind, why
isn't he ruling the
world,then? Eh? Why
bother with this little...
side show?'

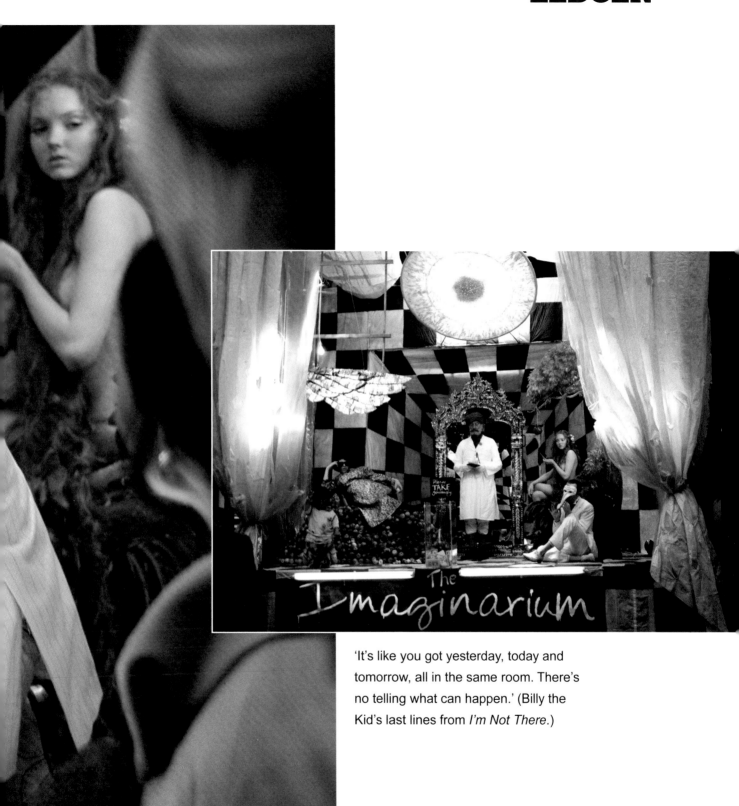

'It's like you got yesterday, today and
tomorrow, all in the same room. There's
no telling what can happen.' (Billy the
Kid's last lines from *I'm Not There.*)

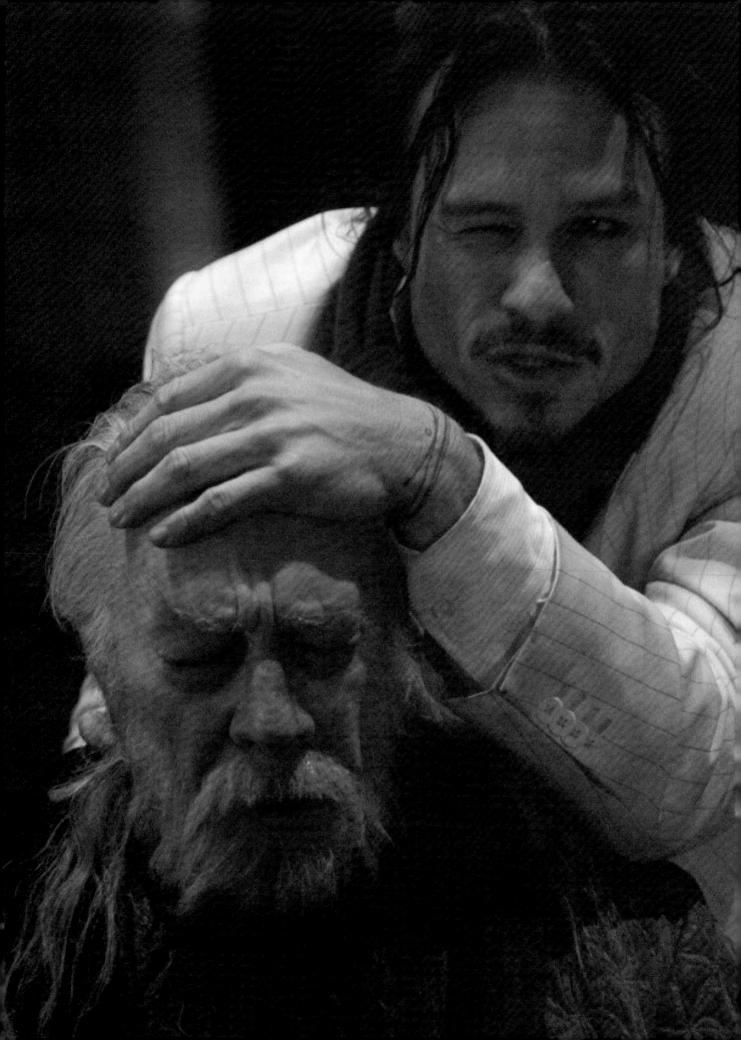

LEFT: 'Can you put a price on your dreams?'

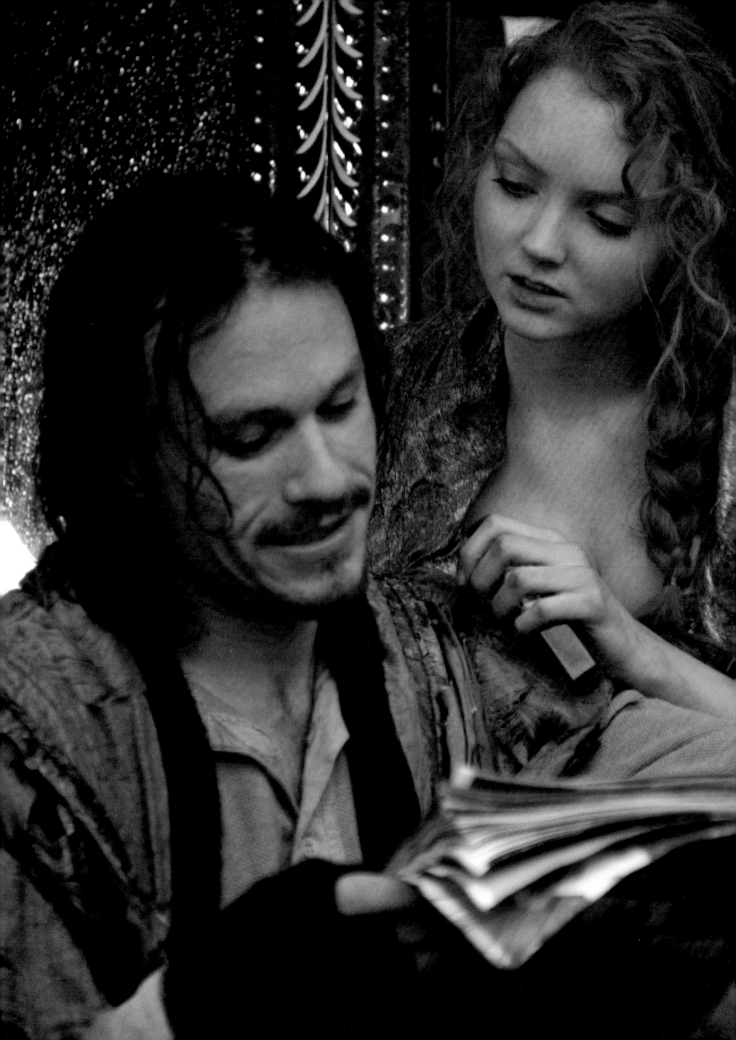

'Nothing is permanent, not even death.'

'Don't believe everything you read.
Especially The Mirror.'

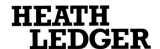

ABOUT HEATH...

Heath has touched so many people on so many different levels during his short life but few had the pleasure of truly knowing him. He was a down to earth, generous, kind-hearted, life-loving, unselfish individual who was extremely inspirational to many.

Kim Ledger, father of Heath Ledger, in an on-camera public statement
after learning of his son's death, in Perth, on 23 January 2008

Mr Heath Ledger died as the result of acute intoxication by the combined effects of oxycodone, hydrocodone, diazepam, temazepam, alprazolam, and doxylamine. ... We have concluded that the manner of death is accident, resulting from the abuse of prescription medications.

Ellen Borakove, a spokeswoman for the chief medical examiner of New York,
Dr Charles S Hirsch, in a brief statement released to the media on 6 February 2008

Today's results put an end to speculation, but our son's beautiful spirit and enduring memory will forever remain in our hearts. While no medications were taken in excess, we learned today the combination of doctor-prescribed drugs proved lethal for our boy. Heath's accidental death serves as a caution to the hidden dangers of combining prescription medication, even at low dosage.

Kim Ledger, in a written public statement, released through Mara Buxbaum,
Heath Ledger's publicist, on 6 February 2008, commenting on Dr Hirsch's
official statement released to the media that day, as quoted above.

*It is tragic that we have lost one of our nation's finest actors in the prime of his life.
Heath Ledger's diverse and challenging roles will be remembered as some of the
great performances by an Australian actor.*

Kevin Rudd, prime minister of Australia

*He was just so respected in the industry. It's just horribly tragic. He was just
a fine actor and a good person, so this is horribly sad and very unexpected.*

Kim Serafin, senior editor of *In Touch Weekly*

*We mourn the loss of a remarkable talent gone too soon...
and the passing of an extraordinary man who will be greatly missed.*

Warner Bros., Heath Memorial, Warner Bros. Entertainment, Inc.,
distributor of *The Dark Knight*

*The studio is stunned and devastated by this tragic news.
The entertainment community has lost an enormous talent.
Heath was a brilliant actor and an exceptional person.
Our hearts go out to his family.*

Alan Horn, president of Warner Bros., and Jeff Robinov,
Warner Bros. studio president

That's terrible…. He was a great talent.

Dennis Hopper

It's really, really sad. I hope his family is okay. I wish them the best.

Charlize Theron

I adored him. I don't know how to compare his talent to others but he's touched me deeply as a talent and it's a great loss – losing him at any age would be a loss but it was pretty rough news. I was really shocked by it.

John Travolta

I deeply respect Heath's work and always admired his continuing development as an artist. My thoughts are with his family and close friends.

Cate Blanchett

I had such great hope for him. He was just taking off and to lose his life at such a young age is a tragic loss. My thoughts and prayers are with him and his family.

Mel Gibson

What a terrible tragedy. My heart goes out to Heath's family.

Nicole Kidman

Once every 50 years a guy like that comes along. For his age, Heath has an incredible manliness about him. I think he has a strong sense of himself, but it's especially amazing in someone so young, because usually male stars don't develop that kind of thing until their thirties.

Brian Helgeland

We tested a lot of people and when Heath came along, he had the same manly qualities Mel Gibson had as a young man. They're never really boys; they already have it.

Roland Emmerich

Working with Heath was one of the purest joys of my life. He brought to the role of Ennis more than any of us could have imagined – a thirst for life, for love, and for truth, and a vulnerability that made everyone who knew him love him. His death is heartbreaking.

Ang Lee

Please respect our need to grieve privately. My heart is broken. I am the mother of the most tender-hearted, high-spirited, beautiful little girl who is the spitting image of her father. All that I can cling to is his presence inside her that reveals itself every day. His family and I watch Matilda as she whispers to trees, hugs animals, and takes steps two at a time, and we know that he is with us still. She will be brought up with the best memories of him.

Michelle Williams

...BY HEATH

I had a year where I sat around on my butt and declined generous offers to do more teen movies and more of the same characters as the one from 10 Things. *I was literally living off Ramen noodles and water just because I was sticking to my guns. It was very hard because they offer you so much money. It's so easy to say, 'Ah fuck it, at least I can live and eat.'*

Interview with *Detour*, Summer 2000

All of this is so insignificant. In the grand scale of things, there have been so many before who have been in this position. I'm just another one. Life is so short. It's like we're already gone, really, in retrospect.

On fame and celebrity, as quoted in the *New York Daily News*, 26 June 2000

[I'm] an extremely private dude and all this is happening so damn quick. I really haven't had any time to rationalize it. But it's nothing that I'm going to let freak me out or take control of me or my thoughts or my real life.

As quoted in the London *Times*, 1 July 2000

I'm in control of my life, not anyone in Hollywood. I only do this because I'm having fun. The day I stop having fun, I'll just walk away. I wasn't going to have fun doing a teen movie again. I don't want to do this for the rest of my life. I don't. I don't even want to spend the rest of my youth doing this in this industry. There's so much more I want to discover.

As quoted in an interview in *Vanity Fair*, August 2000

I'm the worst auditioner, really, really bad. I mean, you're being judged and I'm just so aware of it that it consumes me. I can't relax, I'm tied in knots, so the voice is very taut and tense. You're so aware that you're acting 'cause you're sitting across from this lady with a piece of paper who's going, I'm. Going. To. Shoot. You. If. You. Don't. Blah, blah, blah, in this emotionless voice. It's foul. I hate it.

As quoted by EW.com, May 2001

Sometimes, most often than not, once we start shooting I won't look at the script at all until we finished shooting. It's kind of like it's been imprinted in my head during rehearsals. You just let it go.

As quoted by Reel.com, May 2001

Most of the time you don't even know they're there. Now, that's the scary thing. It's really strange and invading, but I'm still working it all out. I try to not let it bother me. And if I want to swim naked in my pool, I'm still going to do it. I certainly don't want to feel that I have to change everything in my life that I do to cater to them. I just won't let it happen.

Speaking on his problems with the paparazzi,
as quoted in the *National Post*, May 2001

Matilda is adorable, and beautifully observant and wise. Michelle and I love her so much. Becoming a father exceeds all my expectations. It's the most remarkable experience I've ever had — it's marvelous.

On becoming a father to his daughter Matilda, June, 2005,
as quoted in 'Obituary: Heath Ledger', ABC News, 23 January 2008.

I apologize for my terrible interview skills. I wasn't prepared to expose stories about something so special and wonderfully private that is happening in my life. I guess a part of me wishes that I'd never have to and that maybe I could protect this special time. I was dreaming.

Apology from Ledger after he ignored reporters' questions and
focused on peeling an orange, *Sunrise*, September 2005

It's like anything in life, visualizing the old man you're going to become: As long as you have a clear picture of that — the life you want to lead — eventually you'll probably get there.

Quoted in *Variety*, December 2005

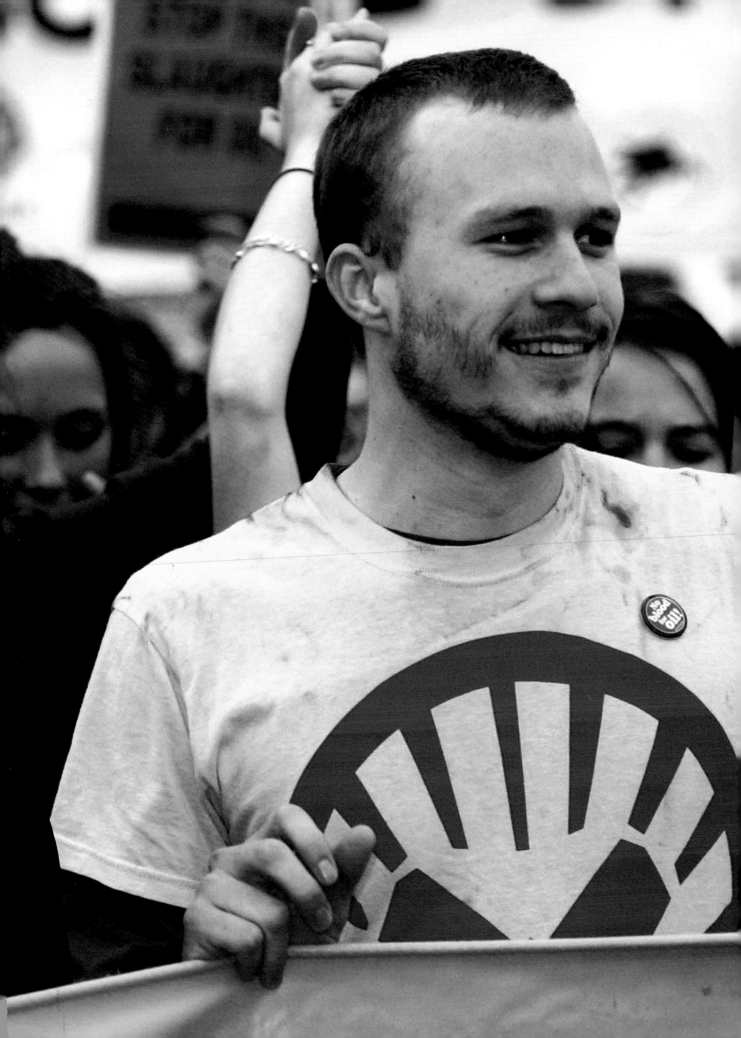

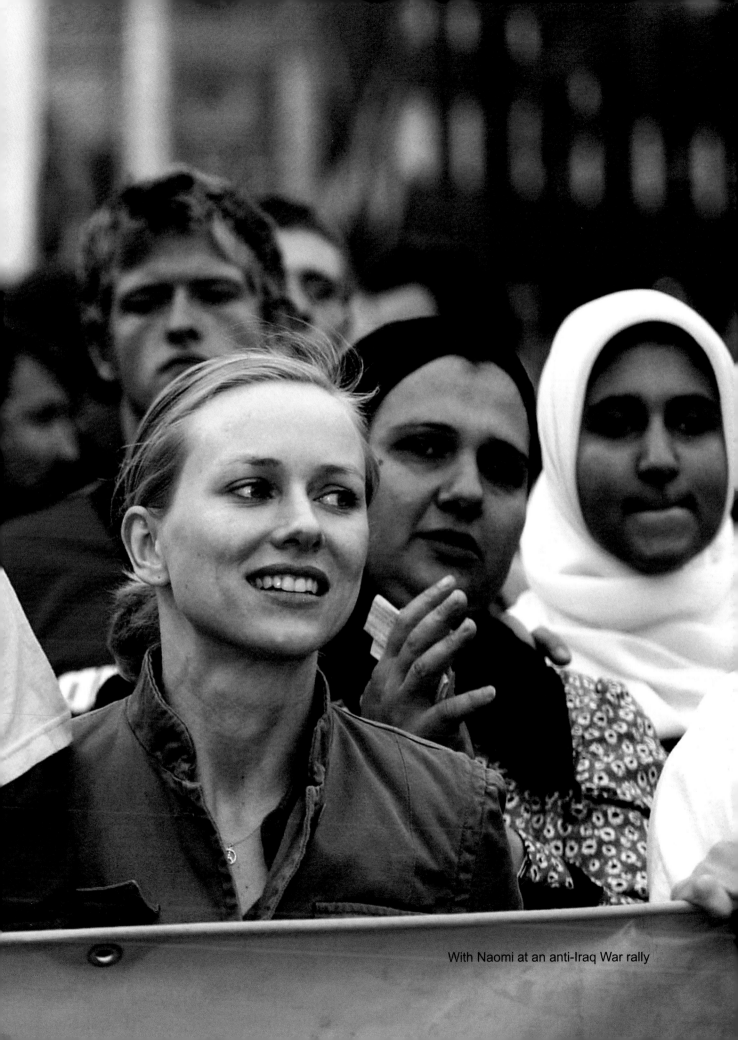

With Naomi at an anti-Iraq War rally

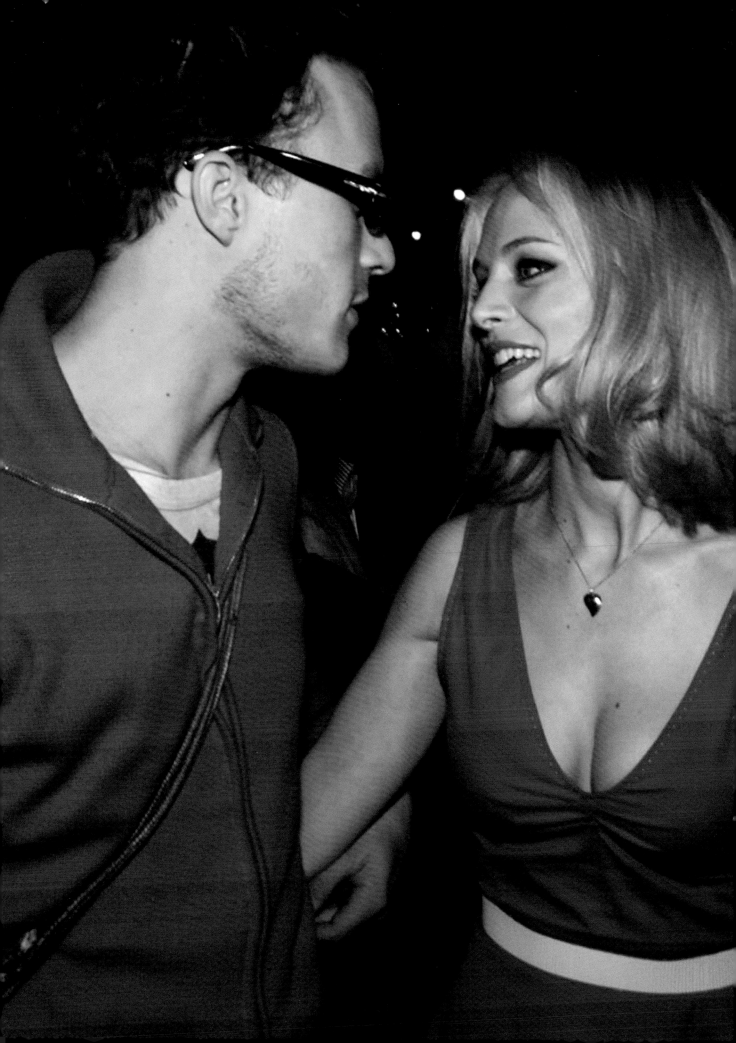

With Heather

INDEX

HEATH LEDGER

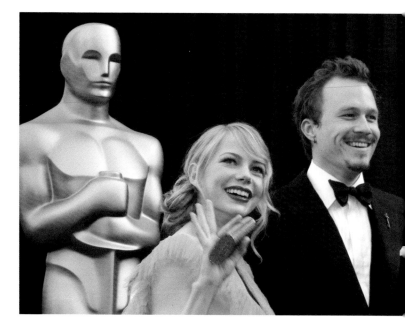

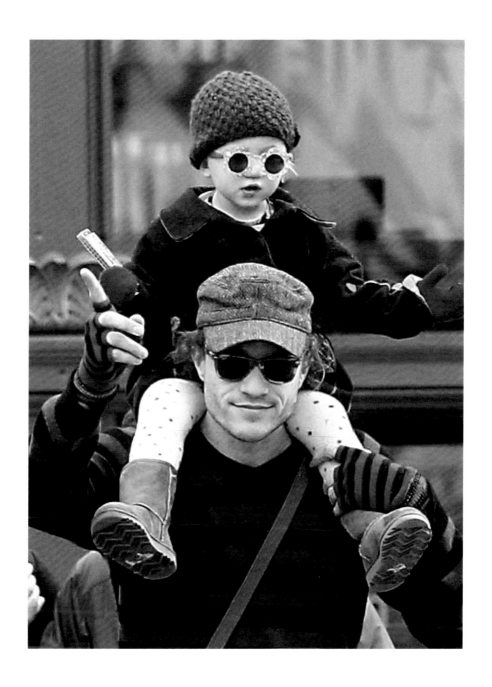